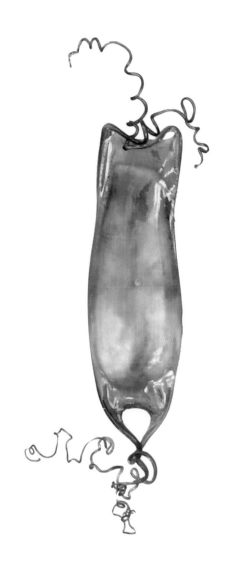

for Saan, Joseph and Erin

For generosity with their time and knowledge, I would like to thank Sue Harmes, Derek Spooner, Mike Petty, Francis Bunker, Heather Buttivant, Dave Conway, Fred Clouter, Chris Halls, Tracey Williams and Gail Austen-Price.

I am also grateful to friends who looked through drafts and gave their thoughts and much-appreciated encouragement, particularly Pamela Dearing, Richard Cowen, Claire Wallerstein, Sue Lord, Jo Ballard, Amelia Van Wijk, Jo Kehyaian, Mandy Walker, Nic Sweetzer-Sturt, Jenny and Kevin Marchant, my mum and Emma Hickman.

For visits to the beach, both recent and long ago, my thanks to Laurie Harpum, my dad, mum and brother, Tod and Karen Checksfield, and Helen, Harry and Rose Barlow. Thanks also to Rame Peninsula Beach Care and Bryony Stokes, Isles of Scilly Seabird Recovery Project, Newquay Blue Reef Aquarium, Polperro Arts Foundation, Sarah Taylor, Rick Connolly and Evan Jones, and to Tracy Watts for the drawings, the Marine Biological Association and Polperro Primary School for the plankton, and Louise Courtnell for the whale.

Most of all I would like to thank Saan, Joseph and Erin for patience, love and the inspiration of their curiosity.

'This beautifully illustrated journal reveals
some of the secrets of our seas and reminds us
why it's so important to protect them'

The Wildlife Trusts

contents

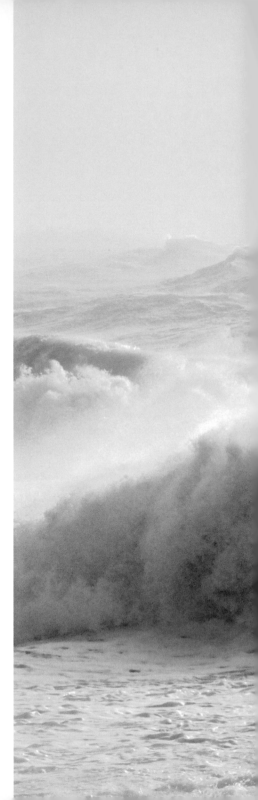

JANUARY

stone giants

At my local beach on Cornwall's south coast, last night's storm has thrown a ridge of shingle against the cliff, allowing me a protected spot closer to the waves than usual. I tuck in against an overhang, in the hope it might keep off the worst of the rain. Beside me, what was a gentle stream is now a torrent, roaring down the beach and carving a deep, sheer path through the sand. The air is filled with spray and sound ricochets off the cliff-faces, filling the tiny cove with a cacophony of river, wind and sea.

There is a big swell running — 15 feet according to the forecasts — and after each lull another huge set rolls in. The most powerful waves are thrilling, unnerving. They rush back up-river, effortlessly rolling and hurling great boulders so they crack against each other with the thunder of stone giants. Waves explode on the sand, and kelp and plastic bottles — then a crate and a work boot — fly past me through the air at head height. It is extraordinary, the first time I have ever been amongst it. The year has begun as the last ended, with yet another powerful storm.

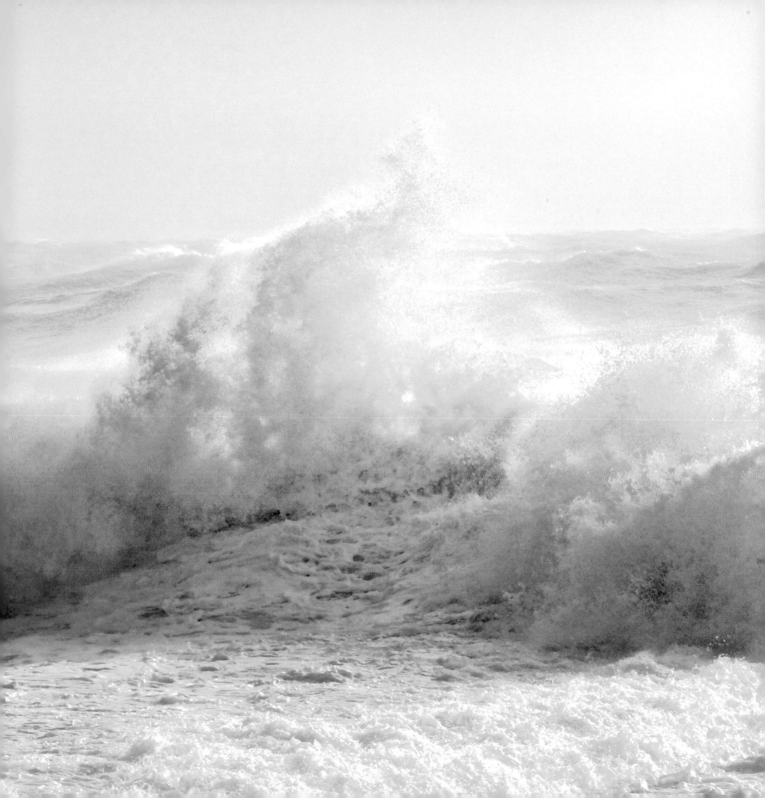

the no-longer common skate

The mermaid's purses lie inside the mouth of a small cave at low tide. Outside, great heaps of seaweed are strewn across the beach. Torn from the seabed in recent gales, their olive greens, ambers and reds are banked against the cliff and sprawl right down to the water's edge. There are slippery kelps, lacy mats and filaments, leathery red rags, all rolled and tangled together. Some I can name: egg wrack, oarweed, landlady's wig, dulse, beautiful eyelash weed – but many more I don't know.

There is no weed in the cave. It is empty but for the mermaid's purses left, as if with care, on the sand. Most are dark and horned, so are the egg cases of skates and rays (those with coiled tendrils are laid by the shark family). I collect them, not yet sure which species they are, and lay them on a rock in the shadow of the cliff to take a photograph. Some are still wet from the dark of the cave and the reflections of the winter-blue sky colour them like paint.

Skates and rays are a group of 'winged' cartilaginous fish known as the batoid fish. In Britain they have historically been rather arbitrarily named (long snout a skate, short snout a ray) and it seems our rays are actually skate, as true rays give birth to live young. The larger species are particularly vulnerable to over-fishing, both targeted and as by-catch, and the world's largest skate – the now painfully misnamed common skate – is listed as critically endangered. In the twentieth century its big, fibrous egg cases, three or four times the size of those I find now, were frequently seen along all British coasts. Now the common skate is virtually extinct off most of England and Wales, and is only really found in Northern Irish and Scottish waters.

The horned egg cases are laid on the seabed – sometimes attached to pebbles by a web-like material, sometimes wedged between rocks – and most take from six to nine months to hatch. As the miniature skate grows it feeds on the yolk, beating its tail to draw in oxygenated water through openings in the horns. Once fully

mermaid's purses: if dark and horned like these, they are the egg cases of skates and rays

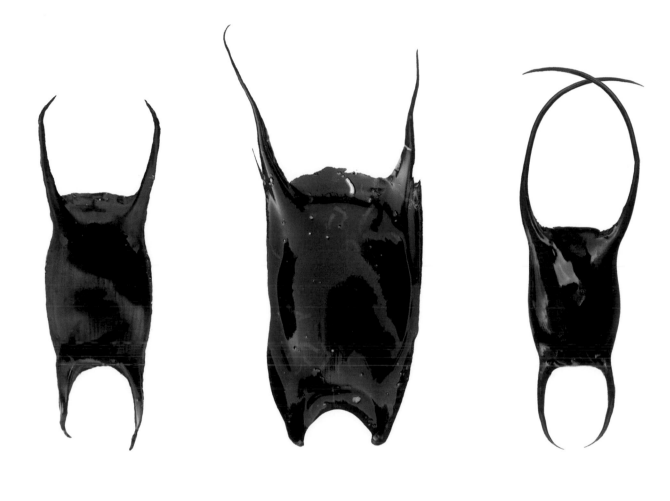

spotted ray small-eyed ray cuckoo ray

grown, the skate emerges through a slit at the top, wrapped in the cloak of its own wings. Happily, all the egg cases I find today are empty, some with a ragged opening where the young skate left. I learn later the majority were laid by spotted rays (one of our smallest, so not targeted by fishermen), the larger by a small-eyed ray and the smallest a cuckoo ray.

Historically, we have had rather a strange relationship with the skate. Since Victorian times whole skate or rays have not been displayed at the fishmongers — only the wings. The reason is said to be that the pale and creamy underside of a skate has a 'face' with lips the Victorians considered too voluptuous, and genitalia 'too similar to our own'.

As a child I remember watching net fishermen standing where the mud gave way to pebbles, cutting the wings from skate before they brought them up onto the beach. I was told they weren't allowed to land the body. It was 'too human' they said at the time, and left it at that. Later, though, I heard more. With the common skate as long as a woman is tall, it was said that for some sailors — who had been too long and too lonely at sea — the sight of a female skate was too much.

drowned forests & lost lands

I go to the nearby beach of Millendreath because I've heard about the trees. It is the third Monday in January — the most depressing day of the year according to the radio — but after months of wind and rain sweeping in relentlessly from the Atlantic, the sun is shining from cloudless blue. 'Days stolen from summer' someone once told me their grandmother called them, and this year they feel particularly precious.

The trees were uncovered a week ago, when violent storm waves stripped the beach of much of its sand. It is low tide when I get there and several part-exposed trunks lie

prehistoric trees uncovered after storm waves drag tons of sand offshore

at the half-tide mark where the sand turns to mud, some drying in the faint warmth of the sun. They don't look extraordinary. I squat down and touch them, and they feel no different to modern driftwood worn smooth by the waves. It is hard to believe they are the remains of a drowned prehistoric forest that flourished here thousands of years ago.

A stream runs down through the valley above the beach, eventually seeping from the sand to run in rivulets out across the mud. In those places where it washes over the trees, the rich detail of the ancient wood is revealed. The running water and play of sunlight magnify the open grain, the whorl of a knot, a break in colour between sapwood and bark.

The remains of similar ancient, submerged forests can be seen all around the British Isles, although often only briefly. Some are revealed only on exceptionally low tides and others – as here – for a short time after a storm, or gales in a particular direction. In places, sometimes for only a few days a decade, the sands shift and the stumps of prehistoric trees stand, absurdly, in the sea or on mudflats.

In the past such sights were hard to explain, and so these places are often rich in myth. Some were known as 'Noah's trees' or 'Noah's Forest', and thought to be a glimpse of lands lost in the biblical flood. In Irish legend the drowned forest off County Clare is the edge of 'The Lost City of Kilstiffen', said to rise above the waves only once in every seven years. Another in Cardigan Bay in Wales is said to be the remains of the legendary sunken land of 'Cantre'r Gwaelod', or in English 'The Low Hundred'. Successive versions of the legend attribute the flood to the negligence of various characters responsible for manning dykes that protected the low-lying land.

The earliest – from *The Black Book of Carmarthen*, written in 1250 AD – blames a maiden for her pride after a feast, while in later versions it is a drunken prince falling

asleep at his post and then a lustful king distracting another maiden (illustrating nicely the shifting weights of society's sins).

Similar inundation legends are found all around the coasts of Northern Europe and it is thought their origins may lie in folk memories of the rising seas that followed the last ice age. As temperatures rose between 10,000 and 6000 years ago, the melting ice caps led to a sea level rise of more than 400 feet. The land was drowning, although due to Earth's changing climate rather than pride, drink or lust.

Slowly, inexorably, the roots of these coastal forests — birch, oak, alder, elm, yew — would have become waterlogged. As bog and marsh plants began to flourish beneath the dead and dying trees, in places such as this — where the wood has been preserved to such an extraordinary degree — the stumps and fallen trunks were entombed in a layer of peat. Formed by decaying vegetation, peat is cold, acidic, anaerobic, which makes it an excellent preservative (several 'bog bodies' thought at first to be recent murder victims have turned out to be thousands of years old).

In recent years gales and winter storms have not only uncovered trees in these offshore peat beds but also the hoof-marks of wild cattle, elk, bear and wild boar, even human footprints. In a tantalising glimpse of our past, footprints found at the submerged forest in Cardigan Bay turned out to have been made between 4000 and 6000 years ago, by an adult and a barefoot 4-year-old.

We are not often reminded that the map of Britain we carry in our minds, the fixed outline we might draw if asked, is no more than a moment in time. Nor that the shores and seafronts we visit now will one day be underwater — although with the recent spate of storms we are a little more aware of this than usual. Alongside news pictures of fallen cliffs, battered seafronts and flooded homes, we are told of the difficulty in predicting the effects of climate change and shown graphics of the jet stream as a ribbon of storms.

One afternoon this week I walked through the nearby town of Looe after it had flooded on the morning's high tide, for the third time in as many weeks. As I passed people mopping out shops, and the sandbags and ruined carpet in doorways, it was easier to imagine a time before those footprints were made, when land was steadily being lost to the sea. Any Stone Age settlements on the coast would — as here — have flooded at first only on an unusually high spring tide, or at the height of a storm. Then gradually, as the ice caps melted and sea levels continued to rise, these inundations would have become more frequent, until there was no choice but to retreat to higher ground.

Ten thousand years ago Britain was no more than a peninsula of mainland Europe, with the Irish Sea, the North Sea and the English Channel all dry land. Steadily, over several thousand years, an area of land the size of Britain was lost to the rising seas. The largest of these is now known as 'Doggerland', named after the Dogger Bank, a sandbank in the North Sea that also gives its name to one of the sea areas in the Shipping Forecast.

Geological evidence suggests Britain finally separated from Europe around 8000 years ago. Following a sudden release of meltwater from a huge glacial lake, and a tsunami caused by submarine landslides, sea levels rose abruptly by more than two feet. As the last land bridges were submerged, marshes to the south became the English Channel and Doggerland first an island, and then the North Sea bed.

For more than a century and a half, beam trawlers dragging their weighted nets across the Dogger Bank have been bringing up some extraordinary finds along with their catches. As well as peat-preserved wood and the bones, tusks and antlers of extinct creatures such as mammoths, aurochs and woolly rhino, fishermen have also pulled up shaped flints and arrowheads made of bone and antler: tools of the hunter gatherers that once lived there. Unlike today, the earlier finds were often thrown back. To a trawlerman from the Christian society of the times — believing the

on my last visit most of the trees have once again been swallowed by the sand

31 Scalp
Bank

S. Sh

ock

Marr
Bank 38

31 Wee Bankie
ay

46

74

46

world was as it always had been — these objects would have been inexplicable, and to many disturbing. The finds, along with data from seismic surveys by oil companies, indicate the Dogger sandbank was once a place of rolling hills, wooded valleys, marshes and lagoons.

On North Sea navigation charts pale depth contours give a shape to those drowned, intangible lands. Marked in fathoms on the older maps (one fathom is six feet) and metres on the new, they follow the undulations of the seabed and so trace the outlines of what were once those hills, valleys and lakes. On current charts the sea is shown as pale where it is deepest, curiously — Pits and Holes and Deeps that maybe once were lakes — and darker blues for the shallower waters where sandbanks lie. As well as the great Dogger Bank there is Little Halibut Bank, Scalp Bank and Wee Bankie, and places named for their depth in fathoms: the Broad Fourteens, a sandbar, and the deeper Long Forties. The meandering contour lines encircling the sandbanks mark the old coastlines of those shrinking prehistoric islands — mudflats and beaches that were once in steady retreat.

There are olive green areas on the British chart too, between blue sea and the pale yellow land. These low-lying areas are for now dry at low water, already belonging half to the sea and half to the land. Often at the mouths of major rivers, many will be amongst the first places to be lost to rising seas. Today, after thousands of years of relatively stable sea levels, there is increasing evidence not only that the rise is gaining pace, but also that human activity is now playing a significant part.

Interactive maps online give an idea of the land that will be lost in future. With a series of clicks a one metre sea-level rise — one prediction for the end of this century — can be increased all the way through to 60 metres, a predicted level if all the ice sheets were to melt. At first blue creeps in over marshes and estuaries, most of them along the east and south-east coasts of England. Then with each rise of a few metres

100
238 *Devil's*
77 *Hole*

the blue moves inland. It drowns coastlines, widens rivers, floods increasingly vast swathes of low-lying land — and Britain shrinks. At a rise of 20 metres major cities are blue. By 60 metres the map is skeletal, the eastern half of England gone but for a string of outlying islands.

A week or so after my first visit I go back to the trees with my daughter, so she can touch them before they disappear. A woman is taking a photograph as we arrive, and tells us she lives nearby and has been researching the trees since they appeared. She says they are around 4000 years old and were last visible after a storm 15 years ago. She makes a wide-open gesture out to sea and tells us they were part of a great forest that stretched for miles along this coast. Back in Victorian times, she says, the beach here was 100 metres further out and tree stumps were sometimes seen at low tide.

On my last visit it is sunny again. I watch a quiet incoming tide run in over the trees, carrying sand grains that come to rest on the wood. The trees are already starting to disappear. Not long after storm waves have stripped a beach of its sand, more gentle 'constructive' waves begin to replenish it, gradually carrying back the sand that was dragged offshore. Soon these remarkable relics will be gone again, seeming to slip back beneath the surface.

wind-sellers

In the past storms like these would have led some sailors and fishermen to pay a wind-seller for more favourable winds. In return, the wind-seller — usually a woman believed to be a witch, or 'spae-wife' in Scotland — would 'tie up the winds' as a series of knots in a length of string or rope, or in a handkerchief. To release the winds the knots had to be untied in a particular order. The first summoned a gentle breeze and the second a stronger wind; untying the third unleashed a violent gale.

55

50 45 38
 29
 31
38 29 30 27
 23

21 17 St

47 18 18

★Mast

17 *DOGGER BANK*

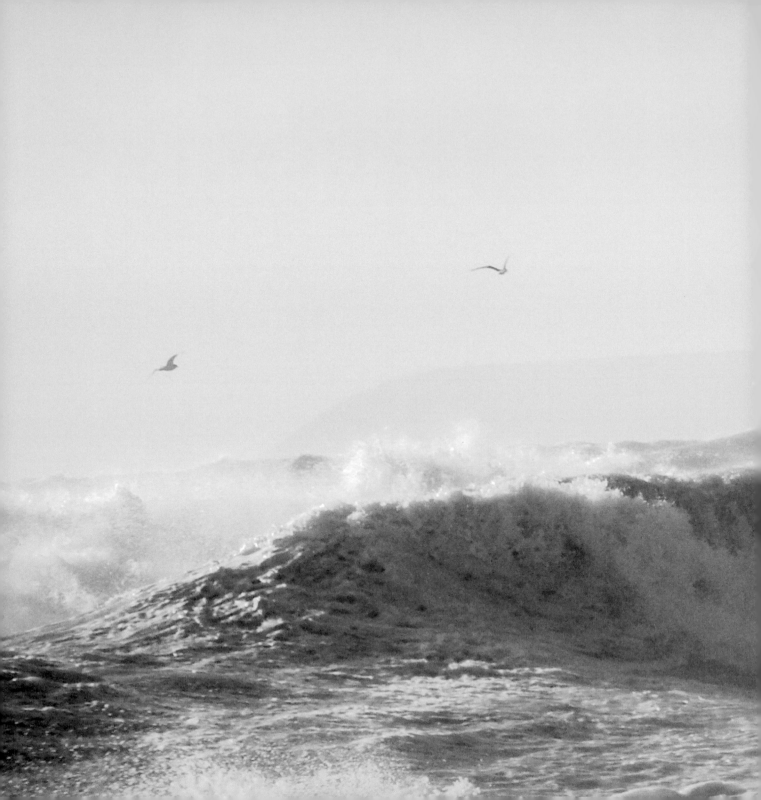

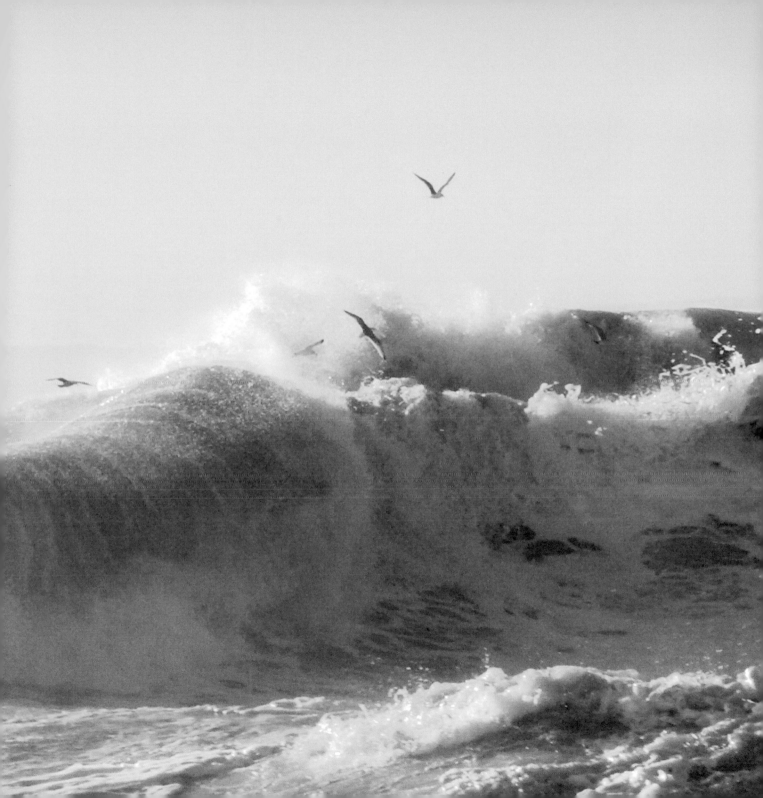

tale of a Lego dragon

Back in Looe one grey Tuesday morning, the closer I get to the beach the more dormant the town begins to feel. The lights are on in the joke shop, but along the seafront the shops are dark. There are still sandbags in doorways and chairs piled on tables in cafes; the ice-cream hatch is boarded over. The main beach is also deserted. Its colours are softened and muted by drizzle, while in contrast bright trails of plastic debris run the entire length of the beach, left by the last high tide. It is like the wake of a disaster, as if the sea had swept through a preschool and smashed all the toys to smithereens. I've seen other beaches like this after gales but never this one, and as always it is a disturbing reminder of all the plastic usually out at sea.

I walk the strandline slowly, stooping to look more closely. Now and then I recognise something — a toy soldier, half a toothbrush, a plastic leg — although my children would be more specific (often knowing which character a body part is from, or the fast food chain that gave them free with meals). Then I see a piece of what I now know is Lego sea grass. I'm still zipping it into my most secure pocket when a few yards away I spot a Lego diver's flipper. It is my first red one, and so considerably more exciting than a blue one. A couple of years ago — like most people — I would have walked on by, as back then I had never heard of The Great Lego Spill of 1997.

For me — and my son — it all began with a black Lego dragon. We found it washed up on a local beach, and as he was about seven at the time it went straight into his Lego collection. It wasn't until we found another one six months later that it struck me as odd, although at the time I thought little more of it. Then a year or so after that I visited Jane Darke — long-time beachcomber and director of *The Wrecking Season* — as she was writing a foreword to the book I'd just finished. Whilst showing me round her wonderful collection of wreck, she opened a drawer and there on top was a dragon, exactly the same as ours (less battered, as it was found a decade earlier).

That was when I first learned their story. It turned out that in the winter of 1997, twenty miles off Land's End, a container ship bound for New York was hit by a rogue wave. The ship pitched steeply and 62 HGV-sized containers were lost overboard. One of them — the one that is best remembered — held almost five million pieces of Lego. Ironically, along with the dragons, these included tiny Lego scuba tanks, life jackets, diver's flippers, octopuses and life rafts. According to the oceanographer Curt Ebbesmeyer, 53 of the 100 types floated (he tested this with a bucket) and so as well as washing up on beaches in Britain, he predicted many would ride the great ocean currents to America and the Antarctic. By now — almost two decades on — he believes some will have circled the Earth, and could continue to do so for centuries.

The Lego still regularly washes ashore in South West England. Some — like today's red flipper — look almost like new, a troubling reminder of the longevity of plastic, even at sea. Eventually, by the time I reach the far side of the beach I also have one more piece of sea grass and three blue flippers, two found inches apart. This seems astonishing to me. Have they been together all these years? Were they first reunited last night?

I walk back fast through town, to the tiny cafe where an hour ago I left my husband drinking coffee. There are three or four of them chatting in the fug and I rush in grinning and lay my finds on the counter with a flourish. They stop talking. I start to explain, rather quickly, why I'm pleased. There is not a huge reaction. They listen, and go back to their talk. I scoop the pieces back up and zip them carefully away. People do not seem as impressed as I'd imagined.

Later though, whilst searching the internet for pictures of what our dragons looked like new, I come across the Facebook page *Lego Lost at Sea*. And there I find a whole community of people proudly displaying their washed-up Lego. Some finds are recent, but others were picked up soon after the spill. There are photographs of the

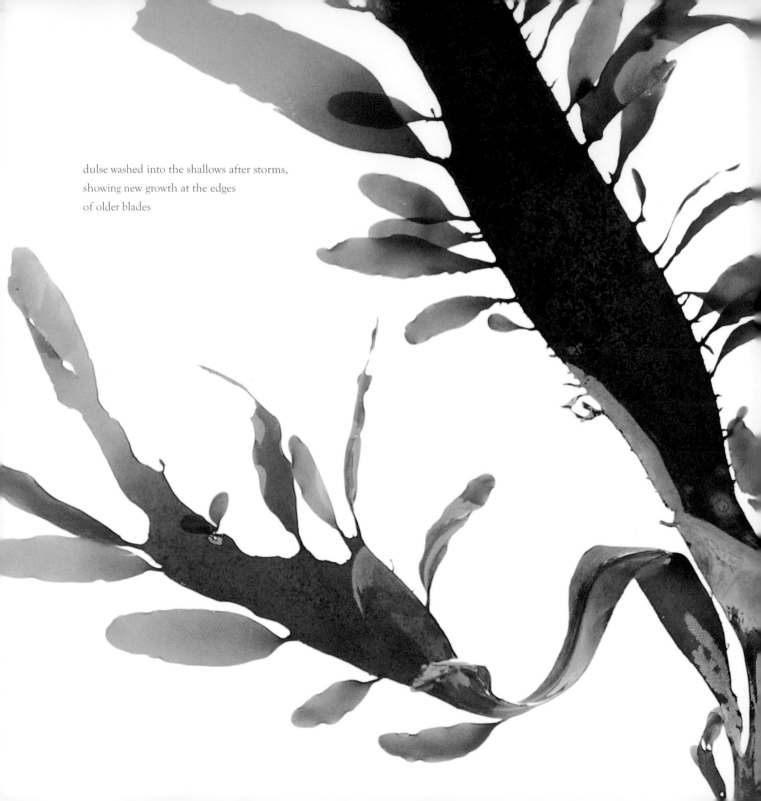

dulse washed into the shallows after storms,
showing new growth at the edges
of older blades

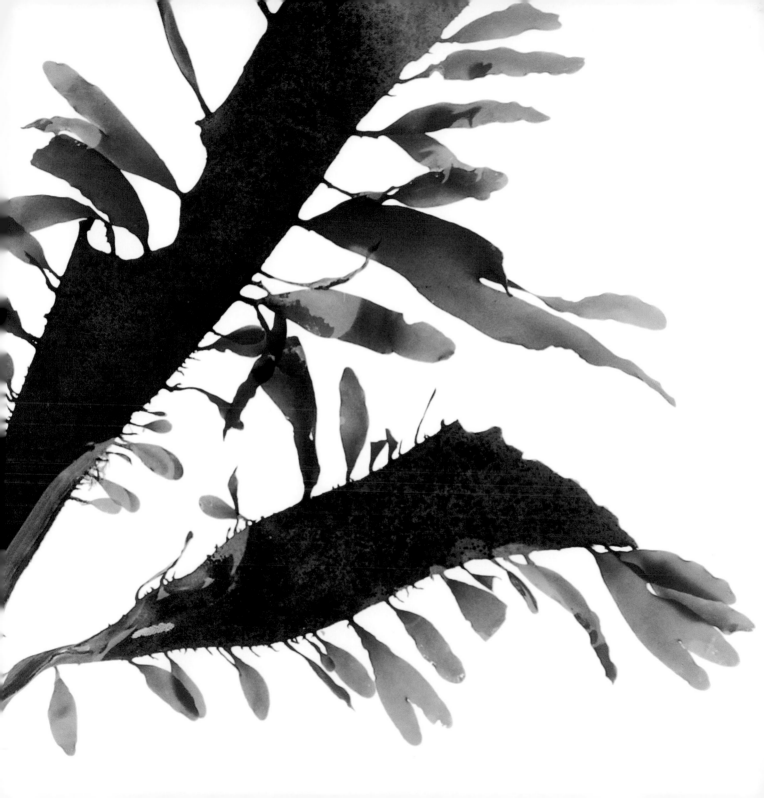

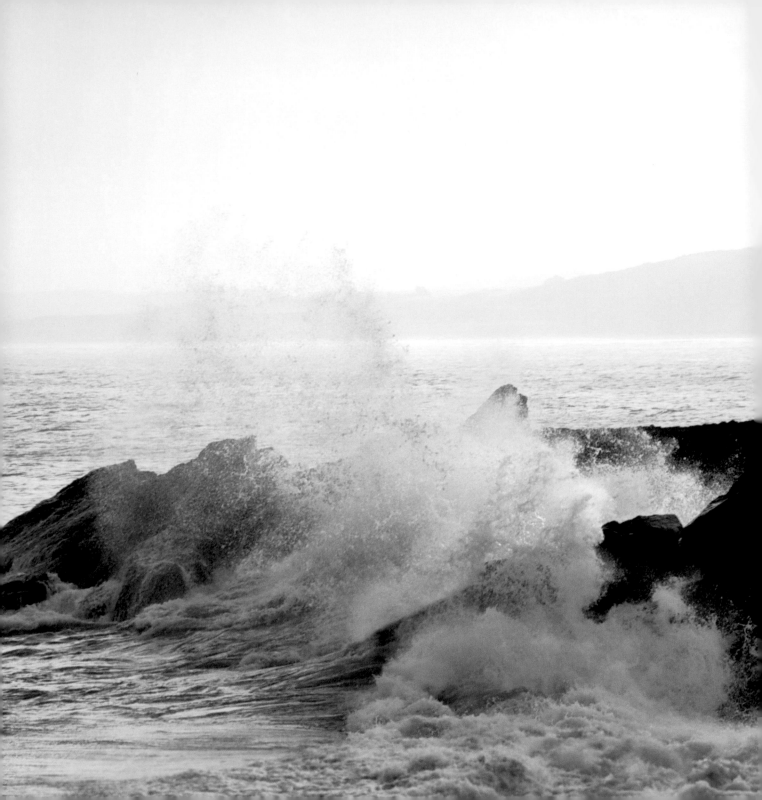

now-familiar yellow life jackets laid out in rows, pirate ship rigging part-buried in sand, and dragons set up on windowsills (back in the late 1990s there were apparently so many dragons washing ashore in Cornwall they would turn up by the bucketful at car boot sales). I find myself checking the page in idle moments, and it's not long before I read of someone finding an octopus in Ireland. I have a twinge of envy. The octopuses are lovely, and they are rare — although the ship's manifest shows it lost 33,941 dragons and 54,000 pieces of sea grass, there were only 4,200 octopuses.

unnamed monsters

On a cold morning at the end of January I visit St Ives to see an exhibition before it closes. I walk first, out around the headland towards Porthgwidden. After recent gales the sea is uneasy, breaking white on the rocks below; offshore its grey-green surface is streaked khaki from the storm-churned bottom.

There is no one on Porthgwidden beach. The cafe is closed and the rows of beach huts are deserted. The narrow curve of sand is strewn with seaweed thrown up in the storms and I follow the highest strandline out across the beach. It is mainly kelp, piles of shining oarweed freshly torn from its seabed anchorage, some still gripping its rock. Amongst it are the holdfasts of another kelp, the wonderfully named 'furbelows' — after the ruffles on a petticoat or skirt, which is what its stipe, or its stem, resembles. Its holdfast is as striking as the stipe, nubbly and hollow, like a toy to be thrown for a dog.

Halfway across I find something reddish, like a small but perfectly formed tree. It even has a trunk. I haven't found one before, but am fairly sure it isn't seaweed. Then — as is so often the case — once I've found one I see more. They are all along the strandline, tangled in amongst the weed. Each is two or three inches high and they come in all sorts of branching forms, most reddish or a dull mustard-yellow;

their stiff texture makes me think they might be sponges. As they're nothing like the sponges I usually find, I put one of each type in my rucksack.

I head out onto the rocks then and for an hour or two watch waves and the fast-changing light, drinking coffee that tastes of the flask. I was last here in July, when the glassy colours inside the waves were all the aquamarines of summer; now they are yellowy winebottle greens. When at last I'm ready to go inside, the sea is silver again, the sky's fleeting blue caught in the shadows and spray.

The Tate stands on the seafront above Porthmeor Beach and I stop on the pavement outside its imposing entrance.
Aquatopia, the poster says. *An Imaginary of the Ocean Deep.*
I take off my rolled-up balaclava and dust sand off my boots with a glove.

In the first bright echoing space I read a John Steinbeck quote beneath a life-size purple shark:
An ocean without unnamed monsters would be like sleep without dreams.
The rest of the afternoon I spend wandering from one clean white room to another, amongst the monsters and mythical creatures that raced ahead of science to populate this place we couldn't know. Krakens and sirens, sea serpents, mermaids, Turner's *Sunrise With Sea Monsters*.

More, though, are creatures we know from natural history, if not from life. There are walls stencilled with squid-ink whales, the eye sockets of a skull studded with wooden barnacles, a resin sturgeon on a bed of trinkets. I spend a long time at a cabinet of intricate glass jellyfish, fanworms and featherstars, all shaped by a father and son with a gas torch in the nineteenth century.

In the main gallery, with my back to the Tate's great curve of glass, I watch a film, *Leaves Swim*. A leafy seadragon — relative of the seahorse easily as extraordinary

as any sea monster — drifts amongst seaweed indistinguishable from the strange, weedy camouflage of its name. On a nearby white plinth are a collection of unremarkable pebbles and shells, all found, according to the label, in the arms of octopuses caught in pots for food. 'Octopuses have a habit of picking up stones and shells from the bottom of the sea,' it says. 'Some octopuses like stones, and others like shells.'

As I turn, I am caught for a moment by the sea itself. I am high above it here and through the gallery's wall of glass it is like a film of the sea. The soundtrack is from a nearby installation, recordings of the strange breathing techniques of elderly women freediving for pearls. I stand with my back to all the art. The sun is out now and cloud-shadows move over the surface of the sea, as if great creatures might be passing beneath.

Then I catch a smell. It is the smell of the sea — soft, atmospheric, evocative. I imagine it to be part of a work and look round for a clue. Then it dawns on me: it's nothing to do with the exhibition. It's me, or rather the sponges decaying gently in my rucksack. I glance over at the people standing closest, not sure if it's only me that can smell it.

above: branching sponges washed up on Porthgwidden beach

sponges, & other barely believable animals

The next day I arrange my small stocky trees on the table and search books and the internet for something similar. Before long I am sure they are sponges — branching sponges — a form seen mainly by divers off Britain's south and west coasts. Found on the seabed in sheltered waters, often on rocky slopes, they are long lived and slow growing, with some species reaching 20cm in height but growing by only 1mm a year. Those on my desk would have survived many storms and heavy seas until now.

I soon find film of the kinds of places they're found, taken by divers drifting through the blue gloom twenty or thirty metres below the surface. It is still down there, quiet but for the soft hiss of the diver's air, and now and then the sound of something moving through water.

As the camera's light passes over a reef it reveals a feathery turf of hydroids and bryozoans, plant-like animals waving tentacles as if caught in a breeze. Scattered amongst them are the sponges: startling reds, yellows and blues in strange, otherworldly forms. Few have common names, but those that do fit them well: yellow staghorn, elephant's ear, mermaid's glove. As the diver's light moves on, their colours fade and they slip back into the gloom.

Sponges are — perhaps surprisingly — animals. Until 1765 they were presumed to be plants, and weren't fully recognised as animals until 1825. We know now they are some of the most ancient creatures on earth, as fossil sponges are found in rocks more than 500 million years old. Simple creatures with no internal organs, they capture food by beating whip-like flagella to pump water into their bodies through pores. They get their curious, irregular shapes from skeletons stiffened by slivers of chalky or glassy minerals known as spicules (page 108). Such simple structures give them an incredible ability to regenerate: if several species of live

sponge are passed together through a sieve — or even a blender so long as it doesn't damage the cells — they are able to gradually reform into the original, separate animals.

Later, in other idle moments, I find myself searching the internet for divers' amateur films of these reefs (it is good that the origin of the word amateur is 'to love'). There is something compelling about these films, a strange, dreamlike quality as the camera drifts over these gardens of barely believable animals. Some of the most striking are the sea fans, intricate and structural, which I know from fragments of their skeletons that sometimes wash ashore (below). Occasionally I

recognise something else, perhaps the soft coral 'dead man's fingers' or the bright, delicate filaments of a 'light bulb sea squirt', and realise how well these too are named. Mostly, though, I have no idea what the myriad species caught in the diver's light might be.

Looking out from shore in January, at Cornwall's grey uneasy seas, it is hard to believe they could be out there.

above: the washed up skeletons of pink sea fans — or warty gorgonians — a type of 'horny coral' that like the sponges were once thought to be plants, but are now known to be animals

FEBRUARY

wavewatchers

The old man comes up to me on a headland in North Cornwall. All around is the debris of Saturday night's storm. The flattened grass is strewn with briny puddles and chunks of the cliff: wave-flung slates and clods of earth and torn roots. An iron bench – in memory of a woman who died 20 years ago – tilts out over the cliff edge, the earth scoured from under its concrete slab. The man walks over to me slowly with his dog. He nods at the sea, says, 'They're saying on Facebook it'll be huge tomorrow.'

So next morning I drop the children at school and walk down the steep hill into Polperro. Still sheltered in the narrow streets of empty holiday cottages, I see no one, hear only the wind whistling through rigging over the roar of the sea. I start to hurry. It is close to high tide and the inner harbour is sleek and brown, impossibly full, pushing a strandline right up into the streets. In the outer harbour the sea heaves beneath a floating island of driftwood and debris, and another wavewatcher's bench.

I head out through the Warren and up on the cliff path to see Peak Rock. I am not the only one. Half the village seems to be out here – dog walkers, fishermen, the owners of the closed cafes and flooded shops, artists, a few parents I've just seen outside school – anyone who doesn't have to be at work this morning. They stand along the path in twos and threes or alone, mostly in silence, facing the sea and the outcrop of rock that protects the harbour.

'Fifty years I've been here,' the man next to me says. 'And I've never seen it like this.' The swell is coming in from the west and Peak Rock is taking the full force of the waves. They explode against it, sending spume right over the top so it falls like fireworks. The rock (page 35) is about the height of a six-storey building but is

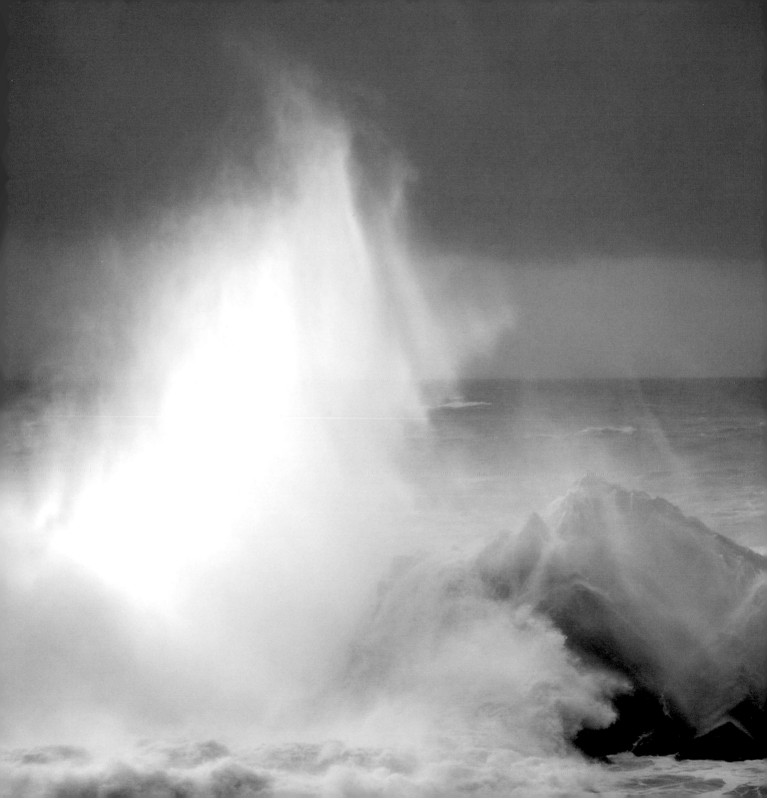

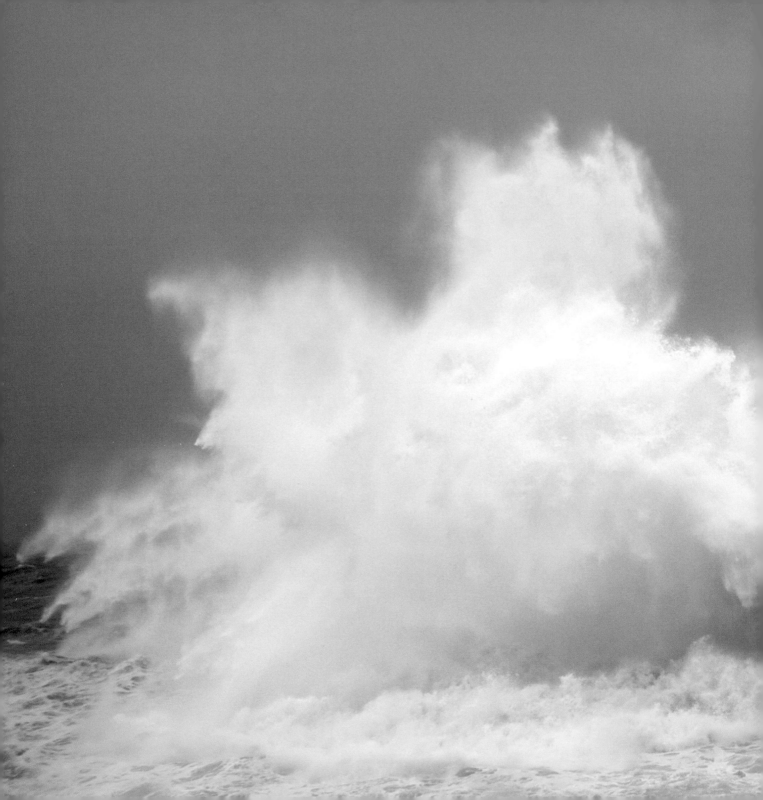

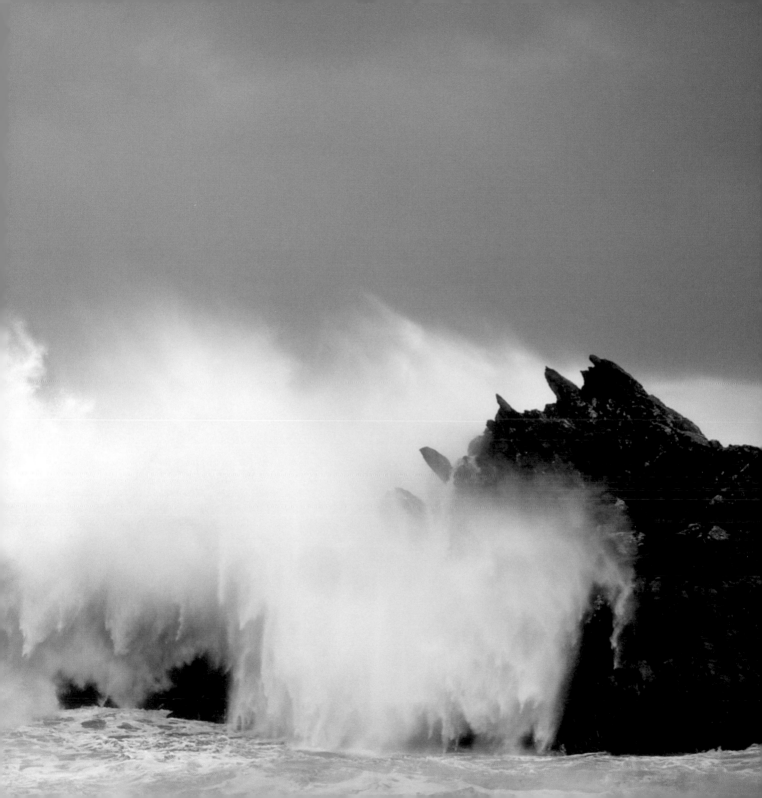

dwarfed by the waves. I lose all sense of scale. When certain waves hit there is a low whistle from the path, a collective intake of breath. Then a lull as the wave crosses the mouth of the harbour. When it slams into the cliff beneath us there is a deep boom and spray is flung up into the sloping gardens; we feel it through the soles of our shoes. On the far side of the harbour the rebounding waves lash the windows of a cottage, but they hold.

The old stone fish stores on the harbour wall are not so lucky — the roof of one has already collapsed (a fortnight later, two more storms, and three have gone). It is a similar story all around the south west, and for a month both local and national newspapers are full of pictures of storm-damaged seafronts and people taking risks to watch waves.

An hour later the tide has turned and fewer waves break over the rock. People begin to drift away. I stay on, waiting for the light, and a particular moment after the waves break, when wind catches the spray and carries it in sheets towards the cliff.
'You should have seen it earlier,' a woman says to a newly-arrived couple watching the sea in awe.

Mid-morning I head back by the inner harbour. It is no longer full, and the retreating tide has left its strandline behind in the street: driftwood, a shredded plant pot, guttering, a shoe — even a fish on the path by the pub (later in the week I read of a seal washed into a local garden and a three foot cod onto a golf course). All month I see similar strandlines, dark trails of seaweed and wood snaking out across coastal roads, car parks and playing fields.

aftermath

A few days after the storm I stop in the nearby village of Seaton, where the beach has moved up into a cafe. It was an odd, rambling place where you could drink

coffee in shelters by an open fire and watch the sea through perspex, still outside but out of the wind. Then the waves and the swollen river moved through. As elsewhere in Cornwall, the beach below has been stripped of its sand, leaving it bare and stony, although here the river and currents mean sand has also been pushed inshore.

I park beside scattered debris and walk out around the sprawl of shelters, slow to take in all the changes. Some are buried in several feet of sand, amidst a wreckage of door frames and planks and broken windows. Drifts of plastic chairs lie in corners, along with buoys and driftwood, some of which once hung on the walls. Out on the front, where we used to sit and watch waves, the splayed legs of a picnic bench poke from the sand.

Every now and then someone wanders through, as if not knowing where to start. I head back — it is too much like looking at a car crash — and through the cafe's open doors glimpse a red ice-cream fridge on a bed of grey sand. I stop, despite myself. Now the sea has gone, and before the clear up, there is that odd stillness of aftermath, of things settled in place. People pass as I leave, pointing, bringing children and dogs. Cars are parked all along the seafront now, right up to where the sea wall lies broken on the beach. There are plenty of us this Sunday morning, come to witness the power of the sea.

voices of the sea dead

Unlike now, in the past there would have been little warning of approaching storms, and so legends of their portents are common. In coastal areas these have often grown up around quite natural sounds — of wind and water, often about a particular reef or cliff — that can accompany the approach of a storm. They may be due to a rising wind, changes in how waves break on certain rocks, perhaps the wind from a certain

direction. Strange and unsettling, in a number of places they were believed to be the warnings of those lost at sea, often in a particular local tragedy.

On Jersey they are known as 'The Laments of the Sea' and are said to sound like the crying of women or children. The sound from the Paternosters reef (named for the prayers fishermen said as they passed it) was said to be the crying souls of five children who drowned there in 1565, when their boat was wrecked on the rocks.

Off the Norfolk coast there is a place at sea where it is said a ship's captain drowned, and a voice comes up from the water to warn of an approaching storm. The sound is eerie, fishermen say, seeming to move as the boat approaches, until at last it seems to come from directly beneath: a sound 'like the last wild cries of a man sinking hopelessly'. A later legend calls the same phenomenon the 'yow-yows' and claims they are the spirits of a number of sailors, drowned when the local fishermen would not go out to save them.

seaweed & fishbones

A week later, driving back from a job, I pull into the deserted car park by Par harbour. From here the walk to the beach is down a path beside industrial land, known locally – I am told – as Dog Shit Alley. At its entrance the contents of a litter bin have been scattered by gulls and beyond that, beneath the railway line, I wade ankle-deep through murky water. Past the corrugated roofs and chainlink fencing though, the winter bushes thicken and meet overhead, forming at last a long dark tunnel to the sea.

I emerge into sunlight. A wide, sea-washed beach stretches away from me, the tide way out and not a footprint in the sand. I am the only one here. It is a spring tide, a month before the equinox, so the night's strandline is high on shore. I head out

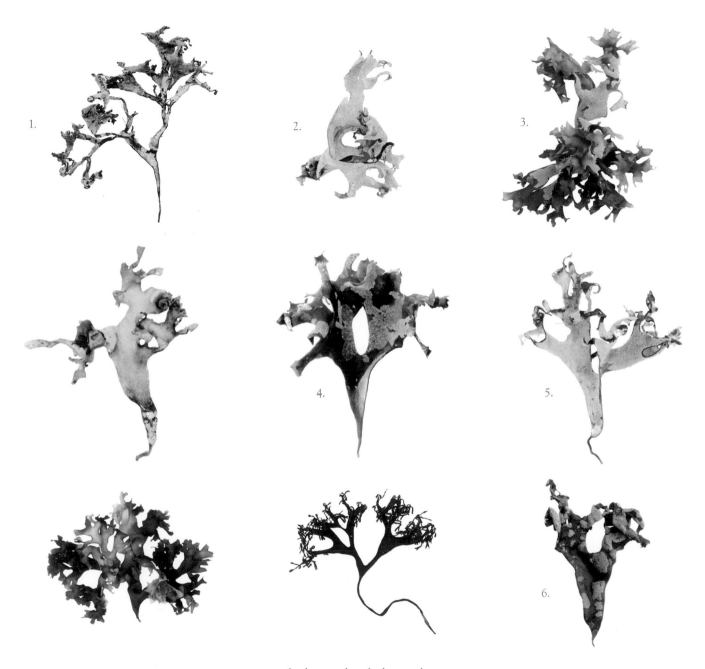

scraps of red seaweed washed up onshore,
2, 3 & 5 encrusted with sea mats and 1, 4 & 6 with the coralline algae 'pink paint'

Irish moss

false
Irish moss

no idea at first what it is

across the rocks of the spit, and though the waves are breaking white far out the rockpools here are still and sunlit, feathered with coral weed or lined with 'pink paint'. In these sheltered pools this encrusting red seaweed forms a hard, intricate patchwork, and where the patches meet they rise up in poorly sewn seams. In one pool I find a top shell encrusted with it, near invisible in its patched lilac coat.

Further out, the wrack gives way to a turf of red seaweeds. The tide will fall so low today it draws me out, promising a part of the shore it rarely reveals. I am already a long way out when the sun goes in. It disappears behind blue-grey cloud, a brief rim of silver then it's gone. The rocks are darker now, the atmosphere changed. I hear gulls shrieking ahead of me, a commotion out at the water's edge. They rise up, scraps of white against the sky, and drop back.

The weed is thick and springy on the rocks here, still wet and shining from the sea. Careful not to slip, I grip handfuls of it and keep my eyes on the rocks. When I reach the water the gulls are gone, and it seems strangely quiet.

First I see part of a spine. It is laid out, strikingly white against the false Irish moss — another red seaweed but so deep a red it's almost black. I look around and there are more bones scattered about, all glistening blue-white and picked clean: a few separated vertebrae, another length of spine, a fish's jawbone lined with tiny teeth.

In a pool is a skull. A fish, although I don't know what species it might be. I often find similar skeletons on a local harbour beach and have always presumed they were discards from fishing boats. Then something catches my eye. It is delicate, translucent, cup-shaped. I think at first it might be a jellyfish. But it's February, and I don't think you see them this time of year. I hesitate before touching it. The thin wall is resistant, rubbery — it definitely isn't a jellyfish. I take a photograph, and after a time walk away, unsure how I might find out what it is.

Then partway back across the shore, suddenly I see. Of course. I laugh out loud on the deserted beach. It is an eyeball, an empty eyeball. I go back and find the skull, check the size of the socket and it fits. I'm sure then – and ridiculously pleased to have realised – it is the eye of a fish, picked clean and dropped by the gulls.

mud, marsh & sky

One wind-scoured afternoon I go back to a beach not far from where I grew up. The drive out is through wide-open marsh on the Isle of Sheppey at the mouth of the Thames, past makeshift stables and sheds and scraps of field. After a sprawl of caravans and chalets I pass through the tiny Leysdown-on-Sea. It has barely changed since I was a child. Although deserted now, in summer there is pub music and the smell of chips, arcade machines wheeled out onto pavements, and stalls selling cockles and whelks by the pint.

The caravans end at an empty car park and I follow a long pot-holed track out across marshes that feel increasingly remote. There is a nudist beach along here somewhere – open to the four winds – but I've forgotten where it starts. I park on a patch of muddy grass and climb the sea wall.

The tide is way out. Beneath banks of fast-moving cloud, estuary mudflats stretch away to the east, sky-shine picking out the patterns left by the tide. Out at the horizon the strip of brassy sea is flat, strikingly different to where I've just come from. In Cornwall storms are forecast for today, wind and rain and another big, damaging swell, with high tide due around now (low tide at one end of the see-sawing English Channel means high tide at the other).

This stretch of the Island is Shellness – 'nose of shells' – and it is well named. There are banks of them, piled against breakwaters put in to stop the drifting of the

beach to the south. The shells crunch underfoot — cockles and slipper limpets against razor shells, oysters, gapers, whelks — the sea-scoured remains of life out there in the mud. Sorted by size, buoyancy and weight, the sea has graded them right down to the shell-sand itself: the pale glisten of the sand here is from their mother-of-pearl linings. I head down the beach to where the stumps of old breakwaters range out onto the mud, rough with barnacles and black against the shine.

I spent a lot of time on mudflats like these as a child, and walking out on the ridged mud now can remember how it felt to go barefoot. Near shore the firm silt surface was often illusion, concealing a slippery grey under-mud that sucked you down, squeezing between your toes and grasping your ankles. It held on, and as you pulled free would suck shut with an estuarine belch. In winter it sometimes kept your boot, and your socked foot would slide clean out, with just time for dismay before it touched mud.

Sometimes my dad took my brother and me cockling. We'd go way out, until we could barely make out the strip of shore we'd left behind, and felt almost closer to the blue haze of Southend and its ferris wheel across the water. Then we'd watch for the cockles to spit. They do this to rid themselves of grit, and I was always told there were so many before the dredgers came that if you closed your eyes it sounded like rain. But by the late 70s we had to wait. Then where they spat we dug, dumping forkfuls of mud on the surface and feeling for the tightly clamped hearts of the cockles.

The other barefoot feel I remember was where the wave-lined silt gave way to the gritty ridge of a sandbank, then its hard flat back where you could run. There were two sandbanks where we lived, one larger and one smaller, and with every tide they shifted just a fraction. It was only noticeable after rough seas or if it was a while since I'd been, but I liked that they changed. Often out on the sandbanks by myself, I knew

them in that way you know familiar wild places as a child, as if they were yours. Very gradually they would move a little further from shore, or maybe closer together, or lengthen or alter a curve. Then at nineteen I left both home and the Island, and whenever I return am always freshly taken aback that they're no longer where they were, and look nothing like I remember.

Back on shore I tread across the heaped shells. At the top of the beach rocks are piled against rusting girders, a sea defence that marks the end of the concrete walls and imported stones that span much of this east side of the Island. I climb to the top, and in the gusting wind there is a trace of rain. The marshes stretch away from me, flat and treeless to the distance, with shining ribbons of dyke between the half-drowned fields. Here and there tussocky grass or the stalks of old crops break the mirror surface of the water.

To the south west the land ends in a jigsaw edge of muddy creeks and inlets. Here the flood tide creeps inland, and the ebb slips near-silently away. Unlike hard, deflecting defences like the walls, during storms marshes absorb the power of the sea. So amid current concerns of rising seas and stormier winters, there is increasing interest in these 'soft' defences. In some of the most low-lying parts of Britain old sea walls are already being breached, returning land to marsh in a 'managed retreat'.

From up on the girder I seem the tallest thing in the landscape. The sky is huge, great banks of indigo cloud moving through on westerly winds. Ten minutes later the change comes abruptly, glimpses of low winter sun before the clear break of a passing front. As the last rain-dark clouds move away, they reveal wisps of cirrus in the washed-clean blue. Meaning 'curling lock of hair', cirrus gets its shape from atmospheric winds that blow its falling ice-crystals into curves. But the old rhymes and the weathermen agree —

Pacific oyster: introduced and out-competing the native oyster

these delicate mare's tails are deceptive, often sign of another low on its way. Quite probably the storm now battering Cornwall's sea walls.

the slipper limpet, and other invaders

Amongst the drifts of shells some of the most common are slipper limpets, their empty shells washing ashore like the hulls of tiny boats. Although abundant in southern Britain now, they are not native to our shores and — as is so often the case — their introduction was unintentional. They began to arrive in the late 1800s, hitching a ride with young oysters brought in from America to replenish our over-exploited oyster beds.

One reason for the slipper limpet's success is its curious sex life, seemingly alluded to in its scientific name *Crepidula fornicata* (our 'fornicate' is actually derived from the Latin for arch, which also meant brothel). When the larva first settles out of the plankton it develops as a male, able to creep slowly about until it finds a suitable home. If settling alone — perhaps on a rock or the shell of another species — it soon begins to change into a female. Often though, the larva is attracted to the back of another slipper limpet, which itself might be part of a 'chain'. There may be ten or more limpets in these long, curving stacks, and considerably more if side-chains develop. Unlike other limpets, after a time they lose the ability to move about and so remain where they are for life, growing to form a perfect seal with the shell below.

The bottom slipper limpet — the largest and oldest — is always female, often forming the base of a gnarled and knuckle-like clump. At the top of the chain, the younger, smaller limpets are always male, and chemicals released by the female can keep them male for up to six years. Each male keeps its long, tapering penis curled behind its head until needed, at which point it reaches down the stack to a female below.

Mid-chain, a number of the limpets are neither male nor female, but in the process of changing sex — so when the bottom limpet does eventually die, the one above is ready to become female in her place.

This new bottom female will often continue to cling to the old empty shell, now forming an unattached chain. Along with all the empty slipper limpet shells, in parts of southern England this is entirely changing the nature of the seabed. As they are able to out-compete many of our native species — such as oysters and scallops — on some south coast beaches there can be drifts of these shells and little else.

They are not our only incomers. On several local beaches I see similar problems with another non-native known as wireweed or — in reference to its Pacific origins — japweed. This stringy brown seaweed forms dense mats that soon clog pools and block light, pushing out the native creatures and seaweeds that once thrived there.

This spread of 'invasives' is a worldwide problem, with new species commonly arriving as stowaways on ships, sometimes attached to the hulls but most often as near-invisible larvae in the ballast water. Mostly, the new location proves inhospitable, or a species has little impact. But just occasionally, having left its main predators or grazers behind, the new arrival will flourish, displacing the native species and sometimes — as with the slipper limpets — causing dramatic change to the new environment. Amongst Britain's current invasives (some of their common names perhaps reflecting our concerns) are Japanese skeleton shrimps, harpoon weed, Chinese mitten crabs, devil's tongue weed and oyster thief. This last is a seaweed, so named because it forms air-filled sacs that can attach to shells; amongst shellfish growers myth has it that if left to grow large enough this seaweed will lift an oyster and carry it away.

chain of three slipper limpets

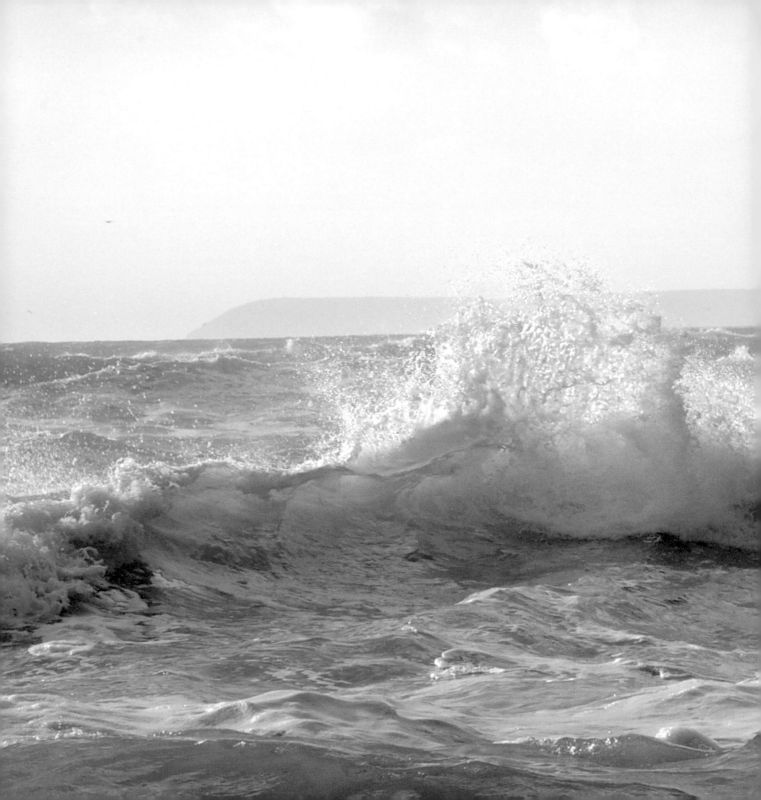

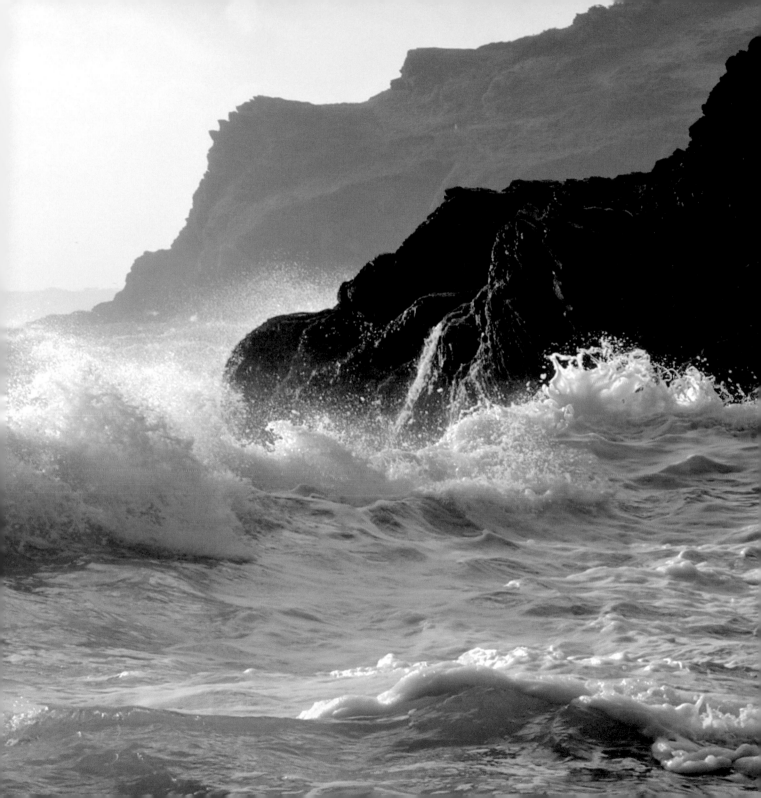

MARCH

plankton
from the Greek, meaning 'drifting or wandering life'

By chance, a few weeks after finding the empty fish eye I find out where jellyfish are in February. As part of a national science week, children from local primary schools are invited to the Marine Biological Association in Plymouth, to 'be a marine biologist for a day'. Happily, the group from my son's class need a parent to drive.

It is an impressive place. Set high on a hill above Plymouth Sound, a tidal inlet, the MBA is a research and education centre, 130 years old and sometime workplace to twelve Nobel laureates. It also has a beautifully named Seawater Hall, connected via pipes to the Sound. The tanks here, some plumbed to be tidal, house an array of native species, including cuttlefish, nursehound sharks and two wonderful curled octopuses.

The first workshop is plankton. The benches are lined with microscopes and the children each take a dish and a few drops of seawater, collected from the Sound an hour earlier. As they focus their microscopes there is a ripple of excited talk. I wait as long as I possibly can, then ask a child for a look.

It is extraordinary, a world I've never seen. The circle of light is filled with strangely beautiful shapes. Most are transparent, their curious forms in glassy outline: circles, tubes and needles, some of them perfect geometric forms, others with bristles or jointed limbs. They jostle against each other, some wriggle or vibrate; one turns slowly full circle. Then something bristled darts into view, careens erratically and is gone. Other shapes are motionless. After a while my son calls me over, and at the centre of his droplet something large pulses in a regular rhythm. It is circular, lobed, and a passing marine biologist takes a look.

phytoplankton

barnacle larva

It is a jellyfish, he says, a moon jelly, but the stage before the 'medusa' form we know: the common kind that wash ashore in summer, that we swam away from in thrilled terror as children. He leafs through a plankton guide and shows us a picture, which is satisfyingly similar to ours.

It turns out moon jellies have curious lives, with very little of it in the familiar form, and my son's specimen is the final stage before adulthood. The jellyfish overwinter as polyps, attached to the seabed like soft corals. As winter ends — around now — there is a strange transitory form, like a stack of delicate saucers. These then peel off, one by one, to float away in the lobed 'ephyra' form we see now under the microscope. As the waters warm in spring, these begin to take on their adult form: the familiar transparent bell pulsing to stay up in sunlit waters, its fine tentacles and 'oral arms' drifting gracefully beneath.

crab larva

By autumn — once the polyp-forming larvae are released, and off to find their winter home on the sea floor — the parent jelly dies. This form, still classed as plankton despite its size, will not be seen again until the following summer. So back in February, there was no way my empty fish eye could have been an adult moon jelly.

APRIL

otter sandstone

One sunny Saturday I drive the children through thatched Devon villages to a place we know nothing about, bunking in on a friend's tabloid newspaper deal: £10 each for an out-of-season weekend in a caravan. We've done it before, although this time the site is unexpectedly genteel, with neatly clipped lawns between the rows of gleaming white caravans. We dump our bags and the kids squeeze into last year's wetsuits, emptying last year's sand on the caravan floor.

diatoms

The beach at Ladram Bay, accessed only through the caravan site, is even more of a surprise. The pebble shore is backed by striking rust-red cliffs, and out in the bay two wind-sculpted stacks stand sentinel, as tall as the cliffs themselves. I learn later this extraordinary red rock is known as otter sandstone, after a nearby river, and really does get its colour from rust, or iron oxide. It was formed from arid desert sands and laid down 200-250 million years ago, when all today's continents were one. As part of the ancient super-continent of Pangaea — meaning 'entire earth' — what is now Britain was landlocked and much closer to the equator than it is today.

The children run straight into the sea. My friend says she'll watch them, so I roll my jeans above my knees and head out rockpooling. The tide is low and still falling, and as it slips below the waveworn ledges at the base of the cliff, I can see they are riddled with holes. The size of thumb holes, most appear to be empty — or occupied by sheltering lodgers — although it isn't long before I realise what has made them. Now and then, deep inside a hole, I glimpse the white shell-tips of a piddock.

This 'boring mollusc' is actually quite remarkable. It drills with the toothed front of its elegant shells, drawing in water to increase pressure then rotating to rasp away at the rock. As it grows, the piddock gradually enlarges its burrow, extending a siphon at high tide but never able to leave. Sometimes, sensing my shadow, or perhaps vibrations through the rock, a nearby piddock retreats further within its burrow, displacing water in an impressive water-pistol jet. As well as sandstone, they are able to burrow into slate, chalk, limestone and clay — the larger holes sometimes found in pebbles of these materials have often been drilled by a piddock.

I cross the bay and head out across sandstone platforms sculpted in beautiful forms by the waves. Those nearer shore are rough with barnacles or green and slippery with gut weed, and in places are invisible beneath intricate reefs built by the honeycomb worm. Like sprawling apartment blocks, these are made from grains of sand cemented with the worm's saliva, and shaped by its big bottom lip. I find part

the seaweed 'red rags' with (*corners clockwise from top left*) Irish moss, sugar kelp, gut weed, sea oak

of a reef still submerged at the rim of a pool and see something I haven't seen before: each entrance filled with a crown of delicate tentacles, catching food as well as grains of sand to repair any damage.

The shore changes as I get further from the beach. There are deeper pools and gullies now, and hollows shaded by wrack-draped overhangs. Most life out here is hiding, waiting out the vulnerability of low tide in all the nooks and crevices of this wonderful rock. I push aside curtains of weed, and half-seen things scuttle back into the darkness. A goby darts behind a stone, the red eyes of a velvet swimming crab withdraw beneath a ledge. Catching movement at the edge of my vision, I see a periwinkle lurch drunkenly to one side: a hermit crab folding itself inside its borrowed shell. Then all is still, as if the pool might hold nothing of interest.

The spring tide is so low today I am able to go further, right out to where oarweed — or devil's apron — breaks the surface. In the sheltered bay the water is shallow and sun-warmed, and there is barely any swell. Its rise and fall stirs the sand at my feet, and the seaweed moves lazily back and forth: sea lettuce and red rags, Irish moss and sea oak. Where the water is deeper, fingers of kelp beckon eerily in the gloom.

I've no idea how long I'm out there — absorbed by the rhythm of the weed, by a decorator crab, by the swaying tentacles of a snakelocks anemone — but when I get back the children are hobbling back up the pebbles, blue-lipped and shivering, showing me white bloodless fingers with pride.

stones & stories

Next morning I wake at 5am to the cry of gulls and the narrow bed's mattress springs. I creep out — careful not to wake any children — and pass between the silent rows of caravans, a few feet from people sleeping behind the thinnest of walls.

shale pebbles with the remains of piddock burrows

The beach has entirely changed. An hour off high tide, the shore is now a strip of pebbles still blue in shadow, the cliffs to the west flushed with the rising sun. I walk as far as the tide allows and tuck myself in against sandstone, out of the breeze. Aside from my intrusion, the gulls have the place to themselves, some soaring effortlessly on thermals, others standing on the beach looking out. Out on the stack's high, wind-sculpted ledges females are spread low over eggs. I sit for a long time, feeling the first faint warmth of the sun as the tide creeps up the beach. As it submerges the last of the sandstone ledges, waves flood beneath it and deep, watery notes echo in the dark.

With each swell, sound washes along the water's edge towards me. Pebbles roll and clack against one another, and with each retreat settle back into place. The sound they make is glassy — the sound of flint — which along with chert makes up the majority of the pebbles here. I grew up by a similar beach, so flint pebbles often felt common, less interesting perhaps than other pebbles. That is until I learned how they form.

Flint is found mainly in chalk, a sedimentary rock laid down beneath deep, warm seas. Although very different rocks, both were once the skeletons and shells of marine creatures, mainly plankton. After death these skeletons drift to the sea floor in what scientists call 'marine snow'. This eventually becomes an ooze, which over millions of years is compressed beneath the weight of subsequent sediment. Where the skeletons are rich in calcium — largely coccoliths and foraminifera — they form chalk. The more glassy silica skeletons — mainly from sponges and the strikingly beautiful plankton, radiolarians — break down to form 'biogenic opal', which eventually forms flint.

The shape of flint pebbles can be a clue to how and where they formed. 'Nodules' develop where the opal collects in crevices or burrows on the sea floor, perhaps

the homes of ancient molluscs, urchins or worms. It also concentrates around a nucleus, perhaps the skeleton of a sea urchin or sponge: if split, a flint pebble can sometimes reveal a fossil at its centre. Occasionally, the pebble itself forms a perfect replica of the creature, such as the fossil heart urchin shown on page 100.

These burrows and fossils also produce flint pebbles with holes, two of which I have in my pocket from yesterday. Known widely as hag stones – or more locally as holy stones, adder stones, lucky stones or eye stones – they have been treasured as charms and talismans since prehistoric times. For centuries they were tied above beds against demons and witchcraft, in particular 'hag-riding'. This sensation of immobility and pressure on the chest – sleep paralysis – is sometimes experienced between dream sleep and waking, and was once thought to be the work of a witch (today it is more often alien abduction). The stones were also worn as amulets and pendants, fastened to the bows of fishing boats and tied above the doorways to farm buildings. Also, looking through the hole was said to make visible a world that can't be seen with the human eye.

I squint into the low sun. The headlands and distant shores to the east, softened now in early haze, make up one of the most extraordinary stretches of coastline in the world. Over 95 miles, a combination of erosion and folding of the rock means that from west to east these cliffs and beaches tell a near-unbroken story of the Earth over 185 million years. This Mesozoic Era, or Earth's 'middle age', turns out to be a time of almost unimaginable change to its landscape, climate and sea level.

The story begins some 250 million years ago, with the rust-red Triassic sandstone at my back. Coming after the most severe of the known mass extinctions – which wiped out most of the life on Earth – this time was a critical period of evolution. As the super-continent of Pangaea started to break apart, life began its recovery. Although fossils from this hot, dry period are rare, those found in the cliffs here include early reptilian ancestors of the dinosaurs.

Twenty miles further east, around Lyme Regis, the rock is grey. These Jurassic clays and limestones tell of shallow seas that formed around the new continents, a more humid climate and a subsequent explosion of life. The rocks here are rich in fossils, giving us ammonites, plesiosaurs, ichthyosaurs – creatures that flourished here 200 million years ago but that failed to survive the most recent of the mass extinctions.

As the continents continued to drift apart, outcrops of younger Cretaceous rock then tell of a new landscape of salt flats, swamps and lagoons, populated by dinosaurs and crocodiles, early mammals and flowering plants. Sea levels rose dramatically and the warm, clear waters supported vast numbers of plankton, their skeletons falling to the sea floor to eventually form chalk. The story ends around 65 million years ago, at the white chalk of Old Harry Rocks, a range of fast-eroding stacks and stumps that once stretched from Dorset to the Isle of Wight. While it includes Old Harry – the largest stack, named for a local pirate, perhaps, or the Devil – the most recent of his succession of Wives is now reduced to a stump only visible at low tide.

oarweed — or devil's apron — breaking the surface on a low spring tide

Faint voices drift down from the cliff-top, along with the first distant sounds of a caravan site waking up. I stand up. The tide has turned now and I head back across glistening pebbles at the water's edge. High on shore, the stones' dry, weathered 'skins' give just a hint of their variety, but down here their rich colours are revealed: red and orange flint, creamy quartz, blue chert, purple quartzite. It seems these colours are from impurities, minerals that leached into the rock as it formed — iron reds, sulphur yellows, cobalt blues — and so to a geologist are clues to where the pebbles originated.

While some are local and easily recognised, like the distinctive pink 'Budleigh pebbles', others have travelled vast distances to be here, borne by rivers, ice and the sea. Although to me most of the geology is a mystery, I do know that every one of them is a fragment of an epic story of unimaginable forces and time scales.

I walk back slowly, readying myself for a caravan full of children.

dunes

At the end of April I meet an old school friend in Scotland and we spend several days on Islay and Jura in the Hebrides. We have come in part for the beachcombing, me for whatever I can find and Laurie for feathers and bird bones. She makes half-cages for them, dries their outstretched wings in the window of her shed, which her elderly neighbour can see from his garden. Last month he called her husband over to the fence. 'Your wife,' he said, with his warm Italian lilt. 'I think she is a witch?'

On our third day we drive a hire car out to Islay's north coast. A long rutted track takes us along the shores of a sea loch, and as elsewhere on the island we pass the stone ruins of abandoned crofts. Some are roofless and skeletal, their families long gone, while others might be lived in but for their blank, glassless stare. We leave the car at the end of the track, setting off on foot and startling a wheatear, which

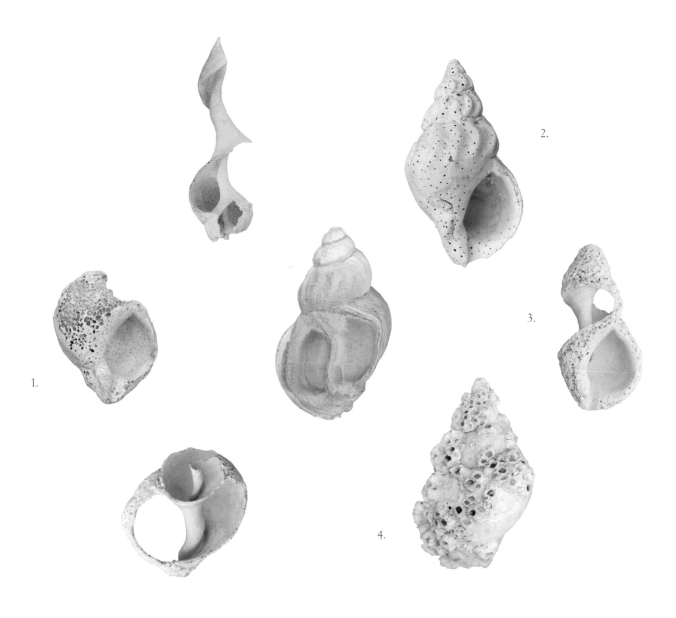

common whelk shells
the holes in 1, 2 & 3 were probably made by the 'boring sponge' and 4 is encrusted with acorn barnacles

16th century engraving:
geese emerging from 'the barnacle tree'

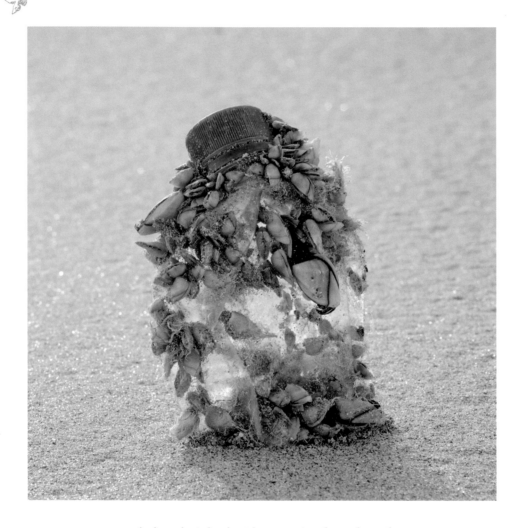

washed up plastic bottle with two species of goose barnacle:
common goose barnacles (larger) and a smaller species known by some as duck barnacles

takes flight with a characteristic flash of white. I learn later its name is not from any resemblance to ears of wheat, but a 16th century corruption of 'white arse'.

We cross a sheltered cove at the mouth of the loch, where drifts of shells collect — cockles and scallops, blue-rayed limpets, whelks, a pelican's foot — then out around the headland's curve of white sand. The unexpected sun and gentle swell belie the harshness of this exposed shore. Facing west, the usual direction of the winter gales here, there is nothing ahead but open water to America. I squint against the glare of the sand, which on these white Hebridean beaches consists mainly of crushed shells and the chalky skeletons of sea creatures and algae.

Below the wind-rippled slopes of the dunes, the humped ridges of old strandlines stretch out across the beach, half buried in drifting sand. There are glimpses of what lies beneath, washed in on the last of the storms: tangled heaps of fishing line and net, plastic bottles, quahog shells, the bleached body of a doll. Most is seaweed though, hard ribbons of kelp, and wrack shrivelled to black sinuous threads; where the woody kelp holdfasts are exposed they are scoured bone-white by the sand. All this chance flotsam — some travelled for thousands of miles, some from just offshore — is veiled, drawn together in smooth sculptural lines by the sand.

We walk east for hours, often hundreds of yards apart in an unspoken agreement to avoid any unseemly race for a find. At times I go on ahead, leaving Laurie behind to don latex gloves and dust sand from the curve of a razorbill spine, or use her tiny penknife to clip the feet from a desiccated gull.

As in Cornwall, occasionally the flotsam I find sprouts colonies of goose barnacles. It is good to find these strange creatures here, as these loch-flats are the over-wintering grounds for many thousands of barnacle geese — and the similarity in the two names is no coincidence. Unlikely as it seems now, in medieval times they were believed to be the same species, the goose barnacle thought to be the embryonic form of the

barnacle goose (when extended the barnacle's feeding legs look a little like feathers). As the geese leave Britain to breed, no one here had ever seen their eggs. The myth persisted, long after it might otherwise have done, as it meant the barnacle goose was considered fish and not meat, so could be eaten during Lent.

At last, by mid afternoon, I reach the end of the beach. Looking back, it at first seems deserted and it is a while before I make out the distant speck that must be Laurie. I sit on the sand, the blue hills of Mull across the water, and eat slices of sun-warmed cheese. The fine sand has been hard walking, and before long I lay my coat on a slope and fall asleep.

Until now I'd barely noticed the breeze, but before I open my eyes I feel grains of sand brush against my cheek. They collect against my forearm, come to rest in the folds of my clothes. It reminds me of the mound we saw on a similar beach yesterday, a smooth hump of sand that covered all but the spread wing-tips of a seabird, its feathers lifting just a little with the breeze.

Although I am a fair way from the dunes, here and there individual blades of marram grass poke from the drifting mounds of sand. It is this pioneering plant that allows the dune systems to form, its deep roots and tussocks gradually stabilising the embryo dunes and so allowing other plants to take hold. Driving out to these west coast beaches, we have crossed miles of this sandy pasture known as machair, and it was a while before I realised that the softly undulating fields were once dunes.

Walking back across the machair, I wonder what lies beneath its grassy surface, what storm-cast relics the old dunes might contain. During severe gales these fragile landscapes might be built up or washed away in a single night, and on occasion will give up their secrets. One of the most extraordinary discoveries was here in Scotland, on the Orkney island of Stromness. During a wild winter storm in 1850, a high, grassy dune known as Skara Brae was torn down by the waves, uncovering the ruins of a village that proved to be some 5000 years old, older than Stonehenge. As well

as stone dressers, hearths and beds — all beautifully preserved beneath the sand — archaeologists found ancient tools, pottery and jewellery.

On the Welsh coast there is the striking sight of the top of a ruined castle keep protruding from grassy, long-stabilised dunes. Once a thriving medieval town, the now small — and further inland — village of Kenfig is also home to the 'upside down church'. As storms and drifting sand began to engulf the original church it was moved inland, stone by stone, and the new church built in reverse, so now the smallest stones are at the bottom. Another church in Cornwall, St Enodoc's, was known locally as 'Sinking Neddy', as for centuries sand dunes engulfed it almost to the roof. To maintain a church's tithe funding a minimum of one annual service was required, so once a year vicar and parishioners would descend through an opening in the roof to hold a service.

razorbill skull

Having grown up on the east coast of Britain, it seems strange to see these marginal places swallowed by sand and not the sea — I am more used to the ocean taking from the land than replenishing it.

seal song

We are almost back at the car — watching oystercatchers pick along the shore, listening to a peewit somewhere calling its name — when there is a low, haunting sound from

the water. It comes again and then again. We stop and look at each other — it is nothing either of us has ever heard before. There is a long, still pause before at last we realise what it is: seal song! In the middle of the loch six or seven grey seals are hauled out on a sandbank, basking in the sun, and singing. And although I quite often see seals near where I live — sometimes 'bottling' vertically offshore, one once that very slowly swam the length of a crowded beach, staring at us all as if astonished — until now I had only read of their eerie song.

guillemot skull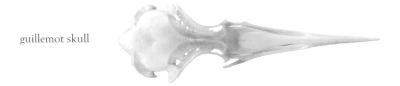

It stays with me long after I leave and I begin to look out the legends of the Selkies, an old Scots word for seal. The tales are common to the Hebrides, Orkneys and Shetland, as well as parts of Ireland. At sea Selkies take the form of seals, but on land can shed their sealskin and transform into beautiful humans. Selkie men are said to be magically seductive, seeking out 'unsatisfied women': one 19th century folklorist wrote that they 'often made havoc among thoughtless girls, and sometimes intruded into the sanctity of married life'.

In the stories of female Selkies, she will often have her sealskin stolen by a man, who then hides it or locks it away. Without it she must remain in human form, often marrying her captor to become a wistful wife and mother always staring out to sea. If at last she finds her skin, there is nothing she can do but return to the sea, sometimes taking and sometimes leaving her children. Having heard seal song now, and seen their dark, intelligent eyes, it comes as no surprise they have inspired such stories.

bird bones

We have been staying in what was an old schoolroom on Islay, and at the end of each day go out into the front garden to look at what we've found. Each evening is the same. I sit on the doorstep in late, golden sunshine with a glass of wine, talking with Laurie as she goes through her bucket of soaking bird bones. She kneels over the murky circle of wishbones and feet, a roll-up in her mouth, flicking bits from the inside of skulls with a twig. I angle myself carefully, so I can't quite see what she's doing. I have begun to feel a little conspicuous, when each day the two of us call in at the village shop and buy more latex gloves.

MAY

the sing of the shore

Early on a Sunday morning I take the children to Lansallos, our nearest beach. It is sunny and the air soft, already warm with barely a breeze. We follow the path beside the stream to the sea, through a dappled tunnel of trees and wild garlic, to where a cutting in the rock opens out onto sand. There is no one else on the beach. The tide is low and the sea near flat; waves lap gently at the curve of grey shore. The stream — raging down the beach in winter — has disappeared and now flows unseen beneath the stones.

After a week of quiet weather the tide has left a delicate strandline. Scraps of seaweed are laid on the sand, and in the warmth of the sun are just beginning to dry out. Thin, membranous fronds of dulse and sea lettuce stretch impossibly between pebbles and shells, and Irish moss has shrivelled to dark fairytale trees. Washing in and out over weeks, drying and soaking with the tide, the colours of the weed fade and change. Most become subtle, mottling in the sun, although a few — as their pigments leach out and break down — become briefly lurid.

Entangled in the drying weed, I see what I think for a moment is a 'squid pen'. These are quite beautiful — the internal skeleton of a squid, a feather-shaped structure made of the same substance as insect wings. But it isn't. When I pick it up it is quite obviously the side of a plastic bottle. It's not the first time I've done this. Once — when I'd only seen them in photographs — I reached eagerly for the skeleton of a by-the-wind sailor, another beautiful structure with a tiny twisted sail, and instead picked up the protective cap from inside a stick of deodorant. And only a week ago I touched (very briefly) what I thought might be the sea-worn joint of a crab, only to recoil when I realised it was a plaster, still rolled to fit a finger or toe.

The children go off to play above the beach then, almost out of hearing, and for a while I am left alone on the sand. I close my eyes to the spring sunshine and gradually the sounds of the sea begin to separate. Over everything is the swash of waves on shore, rhythmic as breathing, and after each rush the hiss of the backwash, as water seeps away into the sand. At each side of the cove the sea laps at the base of the cliff, with all the small playful sounds — almost musical — of water in amongst the rocks.

Each stretch of shore is said to have its own particular sound. In Cornwall this was known as 'the sing of the shore' and was said to be how experienced fishermen would navigate during fog or darkness. In the local social club my dad drinks with a few Cornish fishermen, and mentioned it to them a while ago. They looked sceptical. 'You'd never hear it,' was the response. 'Over the sound of the bloody engine.'

purple laver

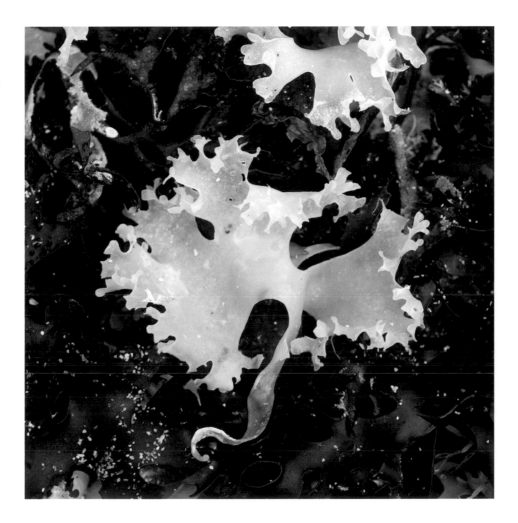

Irish moss, *above and left*: a red seaweed
varying widely in colour and form

false
Irish moss

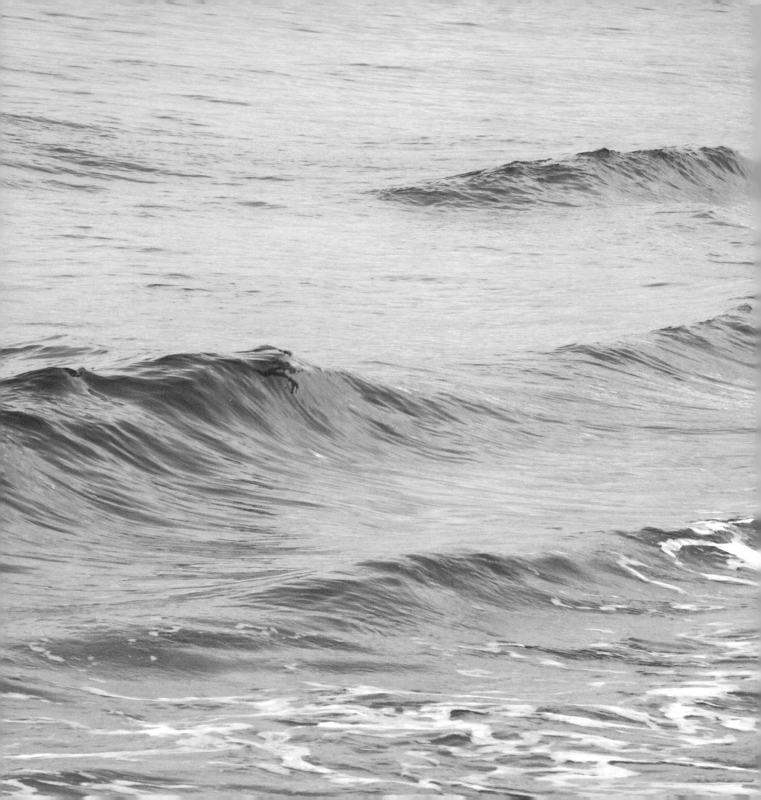

the common cuttle

There have been a lot of cuttlebones washing ashore recently, and I don't know what the reason might be. I came to love cuttlefish in the Seawater Hall, on the school visit to the Marine Biological Association, and it is a particular moment that has stayed with me.

A researcher is about to feed them, and so we gather around the open tank (behind the children, sadly, as it seems inappropriate to join in with the push to the front). Several large cuttlefish watch us evenly, their strangely appealing faces turned towards us, big bug eyes above drooping tentacles.

A live shrimp is dropped in. For a time little happens: the cuttle watches it, ripples its skirt-like fins and drifts slowly, gracefully closer. It appears uninterested, as the shrimp works its legs rapidly and sinks. Then without warning two tentacles flash out from the cuttle at lightning speed, snatch the shrimp from the water and it's gone. The speed is thrilling, unexpected that first time, and the sound the children make is excellent.

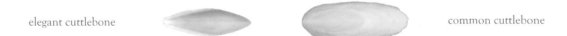

elegant cuttlebone common cuttlebone

Although colourblind themselves, cuttlefish are capable of the most extraordinary changes to the colour and pattern of their skin, which they use as camouflage and to communicate, express emotion and mesmerise their prey. There are tiny muscles attached to pigment sacs beneath the skin (up to 20 million of them) and the skin colour changes as these muscles are flexed and the pigments released. Other muscles

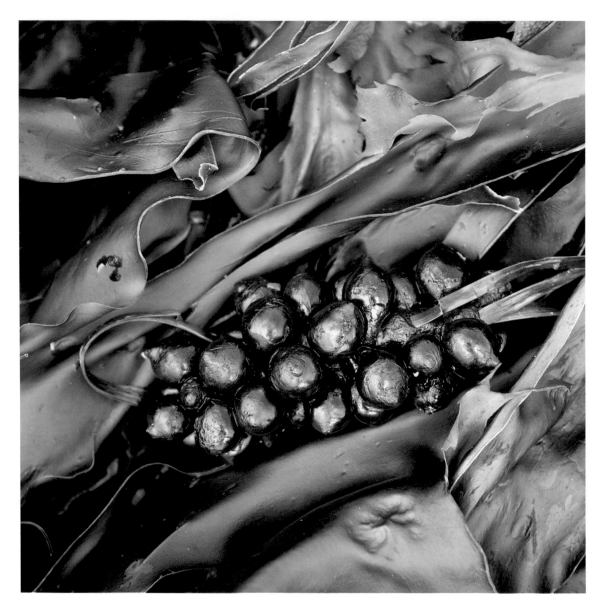

'sea grapes': cuttlefish eggs washed ashore attached to sea grass

are also able to alter the texture of the skin, raising it in bumps or smoothing it out to help the cuttlefish blend seamlessly with the seabed, weed or rock.

During the mating season these colour changes are particularly striking. To warn off rivals a male will ripple and flash with bold zebra stripes, although as soon as he secures a mate his colours change: to a softer, more delicate pattern for the mating embrace. Occasionally, if a male is on the small side, he may choose instead to mimic a female, not just in colour but also by altering the position and movements of his skirts. Incredibly, he is also able to do this only on the side facing the rival male – on the side the female sees he is able to retain his male colouring. Unthreatening to the larger male, he may then be able to nip in unnoticed and mate. Either way, soon after the cuttles have mated and spawned, they die.

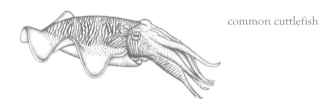

common cuttlefish

I found some of their eggs last summer. Stained near-black with cuttlefish ink, they are known as 'sea grapes', which is exactly what they look like. Bunches of them can be found attached to mooring ropes or lobster pots, sometimes shells or seaweed, or might wash ashore attached to driftwood. Occasionally – although sadly I have never seen this – an egg misses the inking, and it is possible to see inside to the tiny white replica of the adult.

After the feeding in the Seawater Hall, I spoke to one of the researchers there. He had a white coat and white hair, and looked exactly how I picture a Nobel laureate. He told me that although the cuttlefish come into our coastal waters

pyrite ammonites

ammonite fossils
in boulders on the beach at Lyme Regis

devil's toenails

to breed, there is a deep place in the English Channel where they congregate during the winter months. Not long ago, he said, a marine biologist included its previously secret coordinates in published research, and in doing so had inadvertently provided fishermen with the exact location of what is now an important commercial catch.

snakestones, thunderbolts & sea monsters

At half term I take the children to Lyme Regis on the Dorset coast, the first time I've taken both of them fossiling. On the second morning we set out east along the shore until we reach the 'pinch point', where — as we're half an hour early — we can go no further until the tide allows. A young couple with backpacks and hammers are already there, now and then testing the depth of the water against their boots.

Ahead of us the ebb tide has already left the beach and it is fresh after the night's high tide, its pebbles — and hopefully fossils — newly arranged. There is not a soul in sight. In the distance loom the dark slopes of the Black Ven landslip, a part of the cliff that is notoriously unstable, and particularly rich in fossils. I saw a landslide here once, years ago, and it was unnerving despite the distance. I heard it before I saw it, and couldn't tell at first what it was: a roar that seemed to come from all directions at once, and a quarter of a mile away a great part of the cliff was on the move, sliding down towards the beach.

The shore has changed considerably since I was last here, the town waging a constant battle against the encroaching sea. Now the pinch point is a row of great wire cages blocking our way, a number of them still empty — waiting to be filled with rocks to form a new sea defence. After the unusually wet winter there have already been a series of landslips.

Twenty minutes later the couple help us scramble past the cages and we're through. The children set off onto the wide-open beach at a run — not the easiest of ways to find a fossil. When I catch up they are scouring the foreshore, heads down and shoulders hunched, squatting to look more closely. After half an hour, though, they've found nothing and their enthusiasm wanes, visibly. My daughter wanders off to throw pebbles at the sea, and her brother toes the shingle, looking up at cliffs he's been told not to climb.

Then he sees an ammonite. It is grey and flattened, a common kind that washes out of the strangely named 'shales-with-beef' layer of the cliff here; they are apparently known locally — from their scientific name — as 'Arnies'. Then he finds another. And then his sister finds one too, and traces of them in great sea-washed boulders: pale spiral outlines and tyre-like tracks. The children have their eye in now, are converts, treasure hunters. They find a pyritised ammonite with beautifully etched ribs, its fool's gold gleaming in the sun. My daughter collects Arnies in her sunhat, while her brother struggles along with a boulder he can barely carry.

Ammonites are the fossil shells of tentacled creatures similar to the modern nautilus (the name is from their resemblance to a coiled ram's horn). For hundreds, perhaps thousands, of years their beautiful spiral form has captured the imaginations of those who found them. There are a number of places around Britain where they wash out of the cliffs, and in each they were once thought to be magical. Described in 1586 as 'serpents wreathed up in circles, but eternally without heads', in Yorkshire they were believed to be petrified snakes — the heads broken off as they fell from the cliff — and in Somerset fairies, turned first to snakes and then to stone. They were worn as protective charms, and thought to cure everything from snakebite to barrenness and impotence.

Before long our finds include a belemnite, too, another fossil common to the cliffs here. It is grey and bullet-shaped and — as before — once we've found one we see

more. The name is from the Greek for 'thrown dart', and we now know they were the internal skeletons of a squid-like creature that lived 200 million years ago. The fossilised part (something like a cuttlebone) was the 'guard', a counterweight to the creature's head and tentacles. In the past, understandably, these too were a mystery. Widely known as 'thunderbolts', they were thought to be the result of lightning strikes, and like ammonites were considered magical, worn as talismans to prevent the wearer from being struck by lightning or bewitched by demons from the sky.

For several days now I have been reading about Mary Anning, born in Lyme in 1799 and the most famous of its fossil hunters. There is a painting of her in the museum, and descriptions of her in long dark skirts and battered hat, outspoken and unorthodox for the times, scouring the shore and climbing the treacherous slopes of Black Ven. Back home she taught herself anatomy by dissecting fish and squid on the kitchen table. And rather like the Lyme of today, from a stall outside her home she sold her curiosities to summer visitors: as cupid wings, ladies' fingers and devil's toenails.

From the books I get an idea of what finding fossils would have meant back then. In Europe in the early 1800s, and for centuries before, it was widely accepted that the Earth and all its creatures were created by God, in six days in 4004 BC. The fossil shells being found on mountain tops could be explained by the great Biblical flood, indeed were proof of it. According to the Bible, everything that existed had always existed, so any talk of extinction was not only alarming and unpopular, but also blasphemous.

So the fossilised skeletons of the 'sea monsters' that Mary Anning began to dig from Lyme's cliffs were a challenge to the foundations of Christianity. They were unlike anything anyone had ever seen before, and they fitted none of the scientists' existing categories. As transitional creatures in the history of evolution they had fantastic, implausible combinations of body parts.

ichthyosaur skull (1814)

pterosaur (1812) 'an unfeasibly long fourth finger'

Mary Anning's plesiosaur
'a serpent threaded through a turtle'
drawing (1824) by William Conybeare

Mary's first major find was at the age of 12, the skull initially dug from the cliff by her brother Joseph. After a year of searching and then months spent chipping away at the rock, she had revealed almost the entire skeleton: an incredible 17 foot creature that appeared part crocodile, part swordfish, part dolphin, and would eventually be named an ichthyosaur. Although the snakestones, thunderbolts and 'verteberries' were by now familiar, the discovery of this extraordinary creature would have been both fascinating and disturbing.

Twelve years later she unearthed the world's first plesiosaur, a giant sea lizard described as 'even more wondrous' than the ichthyosaur. Its strange, fine-boned paddles and impossibly long neck meant at the time it was described as 'a serpent threaded through a turtle'. Then in 1828 she found the first British pterosaur: a 'giant winged lizard', like a cross between a reptile and a bat, whose membranous wings would have stretched from its ankles to its unfeasibly long fourth fingers. The following year, from the blue-grey mud of Black Ven, came a 'chimaroid', a strange, long-snouted creature proclaimed by scientists at the time to be first a reptile, then a bird, and finally — as it is classified today — a fossil fish. So impossible did these skeletons seem, that unsurprisingly many at first thought they must be fakes.

As a poor and uneducated woman, Mary was excluded from the scientific community throughout her life, and her part in the discovery — and subsequent meticulous cleaning — of the fossils was rarely acknowledged. Her extraordinary finds, though, were among those drawn on by Darwin in *The Origin of Species* as evidence of evolution.

Walking back along the shore, my son picks up from amongst the pebbles a vertebra almost as big as his sister's palm. It is heavy and sea-worn, and we learn later it is from an ichthyosaur, one of Mary Anning's sea monsters that two centuries ago helped change the way we understand the world.

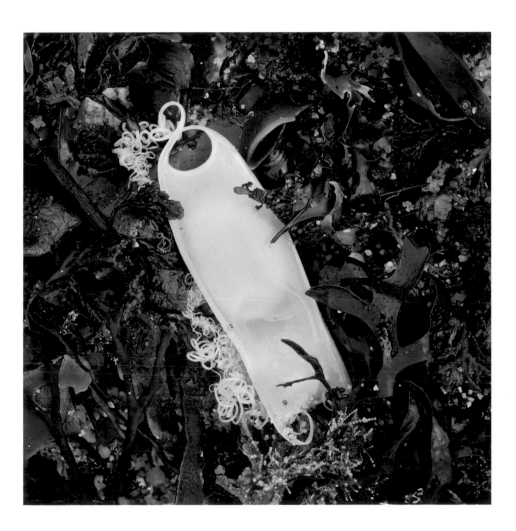

a few days later I find a dogfish egg case on the strandline,
with the yolk inside still visible

closed barnacle doors

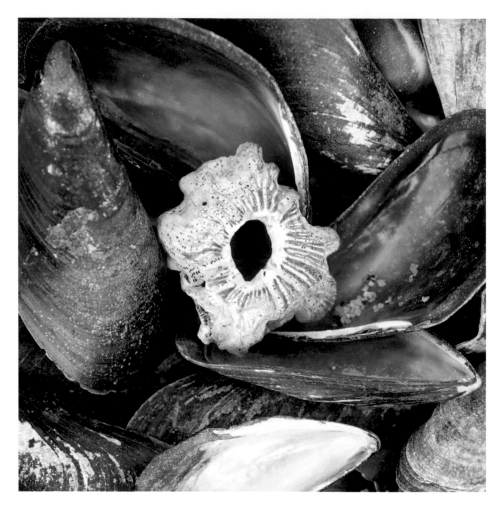

volcano barnacle
washed up with mussel shells

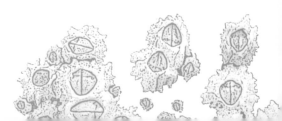

barnacle doors

It is a weekday morning and I am out on a sheltered reef, the sun low over a calm blue sea. The tide is coming in, and the air is so still I notice all the small sounds of its advance. It creeps ashore, its progress barely perceptible, the water slow to find new ways across the rocks. Then a wave is bigger — barely so, but enough — and in a rush of cold it pours into a faintly warmed pool.

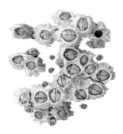

acorn barnacles

I stay ahead of the incoming tide, and with the sun still low in the sky, cast a long blue shadow towards the beach. After a while I am aware of another sound, that isn't the sea. It is muted, a series of wet creakings that stops whenever I do. I start, stop, start again and the sound moves along with me across the rocks, always from the direction of the shore, and my shadow. I read something years ago and remember wishing that I'd heard it: that if you listen carefully you can hear the sound of barnacles closing their doors more tightly as you pass.

The rocks are rough with acorn barnacles here, but they're tiny. There's little else it could be, though. I walk and stop again, listening intently — on the quiet beach the sound is distinct, moving like a wave along the rocks with my shadow. Then silence again when I stop. Barnacles closing their doors! That must be what it is.

JUNE

Mr Arthrobalanus

After that, I develop a bit of a thing about barnacles. I search bookshops and the internet, and watch some wonderful film of them feeding with their feathery feet, and mating – which is both extraordinary and unexpectedly beautiful. Although I do wonder briefly what someone might think if they come in and catch me watching barnacle sex on the laptop.

Then after a while I come across a secondhand copy of *Darwin and The Barnacle* by Rebecca Stott, and learn the story of Mr Arthrobalanus, which was Darwin's nickname for a species of barnacle that played a crucial role in our understanding of evolution.

In 1834, mid-way through his five-year voyage aboard The Beagle, a 24-year-old Charles Darwin picked up a shell on a beach in Chile. As it was peppered with holes he took it back to the ship to examine and there, beneath the microscope, found a tiny creature curled inside the holes. Whilst in all other respects it appeared to be a barnacle, it had no shell of its own, and in the existing system this was an anomaly. At the time all barnacles were classified by their shell type, so there was no place for Mr Arthrobalanus.

By his mid-thirties, back home in Kent, Darwin had already sketched out his groundbreaking theory of evolution, but wasn't ready to publish it. So controversial were his ideas, that in order to be taken seriously he felt first he must prove himself to the scientific community. So he sealed up his theory in an envelope – along with instructions to his wife for its publication in the event of his death – and returned to Mr Arthrobalanus, safely stored away in his collection for the past nine years.

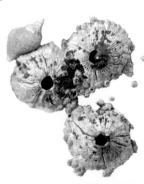

volcano barnacles

As it turned out, Mr Arthrobalanus was a much greater puzzle than Darwin could ever have predicted. In the end, to fully understand this tiny anomaly, he had to map and compare all known species of barnacle — from their ancient fossil shells to the hundreds of living barnacles found across the world, not just on rocks but also on the hulls of ships, and on flotsam, turtles and whales.

So he put the word out — to colleagues, scientists and collectors — and soon specimens began to arrive at his quiet village post office from around the world. The shelves of his study began to fill with boxes and slides and stoppered bottles, and on his wheeled stool he travelled between his writing desk and the dissecting table. There, beneath the microscope, he teased out all the barnacles' minute body parts — feeding legs, intestines, ovaries, cement glands — fixing them in place with tiny pins.

Barnacles, it turned out, had been an excellent choice. With the aid of the new, more powerful microscopes, the variety he found was beyond anything he could have imagined. There were so many differences in the barnacles' anatomies, so many ways in which they had evolved — to reproduce, for example. Some were astonishing, not least a species with 'complemental' males that live parasitically on the females, and others with the longest penis (relative to body size) in the animal kingdom.

As the specimens continued to arrive, Darwin remained driven, completely obsessed with his task. Until he had finished with the barnacle, his theory of evolution must remain locked away, sealed inside its envelope. In the end, the barnacle work he initially thought might take months took eight long years. In 1859 *The Origin of Species* was finally published, and in the preface Darwin tells of his barnacle years in order to 'show that I have not been hasty in coming to a decision.'

buoy barnacle

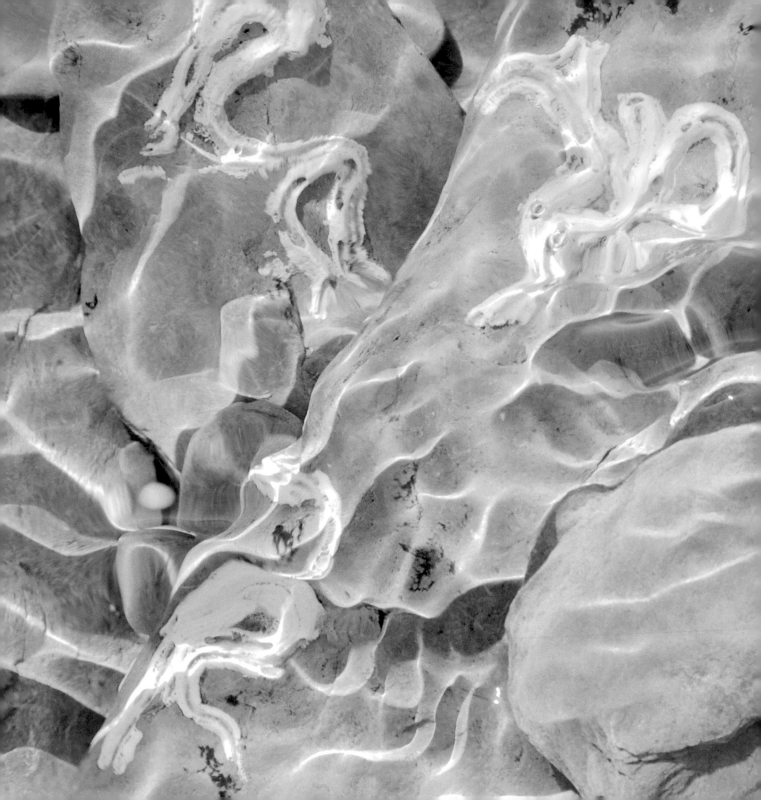

recovery

On Cornwall's gentler south coast, sheltered by Looe Island, the shore at Hannafore is one of the richest places I know to go rockpooling. This is the first time I've been since the storms, when I remember watching the wild turmoil of crosscurrents from the beach and wondering how anything would survive.

Although a few times a year the tide falls so low you can wade knee-deep to the island, today I just wander through the shallows. With the tough older seaweeds torn out over winter, there has been a rush of new growth. Strewn about like the contents of a fancy-dress box, the weed drifts to and fro with the tide: gossamer veils and scarves, unravelling ribbons of gut weed. I trail a hand through the water and some is so fine it is like touching nothing.

Heading for the rockpools nearer shore though, there is more evidence of the violence of the storms. On many rocks there are still traces of the communities that lived on or under them, destroyed as they were rolled and smashed by the waves, the rocks then left upside down or in water too deep or shallow for survival. I find bleached patches of coralline algae and the battered white scrawl of keelworm tubes, their vulnerable inhabitants long gone. There are broken shells, crushed fragments of crab.

As I begin to peer into rockpools however, carefully lifting stones and drawing back weed, I glimpse in these miniature worlds a thriving new generation. There are impossibly delicate brittlestars, several of them re-growing lost arms, and a crab with a shell like a baby's fingernail. Clinging to weed I find tiny snakelocks anemones, and the fuzzy green balls I now know are bristleworm eggs. When I turn

left: slate pebbles with the remains of keelworm tubes (the white squiggles). In life the worms open the tube entrances and extend delicate tentacles to catch food

one rock, tiny squat lobsters — smaller than I've ever seen before — rush backwards to escape the light.

On other rocks, crowding at the edges of grey patches of acorn barnacles, I find their delicate, pure white juveniles. Not long settled out of the plankton, they are so small I need reading glasses to see them. With the slight magnification I can just make out their walls and trapdoors, initially built within 12 hours of the larva's arrival, once it had cemented itself head-first to the rock. When the tide returns these tiny trapdoors will open, and feathery feeding legs emerge to sweep the water for food.

After all the devastation near shore, the next generation — millions and billions of microscopic larvae — were drifting unharmed at sea, ready for what seems to me a remarkable recovery.

sea fog & jellyfish

I go with the children to meet friends at a North Cornwall beach. At high water it is a small, rather stony beach, but for a few hours either side of low tide it opens out onto miles of firm sand. We make a pile of our beach things and wait for the tide.

The last time I was here it was autumn, and raining. I was with my mum, wading through the shallows wearing black bin bags with holes cut for arms, as we'd forgotten to bring raincoats. Today is hot and sunny, though — unusually hot for Cornwall — and there is little wind and barely any swell.

With the sea still relatively cold these are perfect conditions for a sea fog. Fairly common on this Atlantic coast, they are even more so on Britain's colder North Sea shores; it is known there as a haar or sea fret. They form most often in spring and

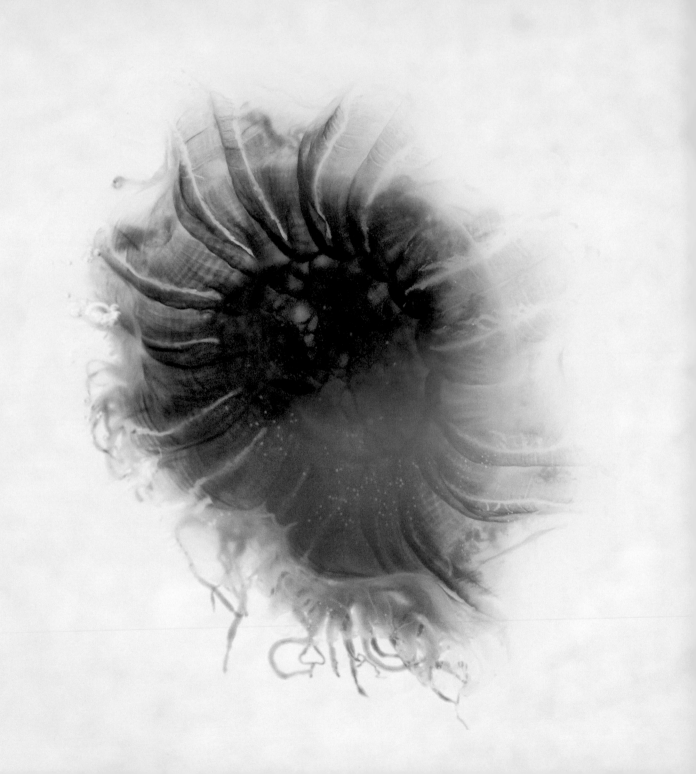

early summer, before the sea has had a chance to warm up, and whilst they may hang over the shore all day, they disperse readily once they reach warmer land. Thirty feet from the beach, the sun may well be shining.

For some time after we arrive the mist sits out over the sea, as if waiting. It is a strange, almost indigo haze obscuring the horizon, and it seems unsurprising that so many legends have grown up around spirits and enchanted islands concealed by such a mist. Its approach now is barely perceptible, until pale wisps begin to drift up the beach.

skeleton of a by-the-wind sailor

At first it is hazy, scattering sunlight, but gradually it closes in. People out at the water's edge begin to fade, become spectral, until along with the sea they disappear. Nearby a ghostly family plays cricket. Shapes appear out of the mist, become familiar if they pass close by: a boy dragging a body board; an elderly couple holding hands; then something tall and for a moment monstrous that resolves into a man with a toddler on his shoulders.

Once the tide is low enough we head east along the shore, and everything is different to the last time I was here. The high cliffs above us are pale, without detail as if cut from grey paper. Today they reveal only gradually their waveworn bases: caves entirely submerged at high tide, with seabed floors and pools that shift with each tide. There are lone, mussel-encrusted rocks, and a wave-cut tunnel where we wade knee-deep towards the light.

left: blue jellyfish (not always blue) stranded in a tide-pool

Today the ebb tide is gentle – I am more used to crashing Atlantic surf here – and has left behind a drift of the delicate internal skeletons of by-the-wind sailors (previous page). Their intricate base and sail are made from chitin, the same material as insect wings, and they sit stranded at the edge of a tide-pool: five tiny, skeletal sailboats.

The tide has also left jellyfish. Several washed into the shallows earlier, most of them moon jellies at the end of their lives, no longer pulsing but drifting in and out with the waves. I watched one tumble gently ashore beneath the surface, its jelly-like bell near invisible but for four lilac loops. Almost imperceptibly, it was left by the retreating tide, one last wave drawing back then seeping away to leave the glistening jelly on the sand.

There are more here, stranded in a tide-pool by the cave, and whilst some float, others are beginning to sink. Although most are moon jellies there are two I haven't seen before. I learn later they are blue jellyfish (confusingly, they may also be purple or white), which prefer cooler waters so are more commonly found further north. These too no longer pulse, and in the deep still pool hang suspended just beneath the surface, a deep indigo with the bells just beginning to fray.

The children, and by now there are quite a few, soon realise the dead moon jellies don't sting (when alive, for most people the sting is at worst no more than a nettle's). They start to collect them – for some reason the 6-year-old calls them all Steve – which soon degenerates into the Jellyfish Wars, which are probably best left undescribed.

JULY

sunfish, jellyfish, carrier bags

This summer there are a lot of anecdotal reports of more jellyfish in British waters. As well as moon and blue jellies, there have been plenty of sightings of other species,

sometimes in large numbers. I came across a compass jellyfish earlier this month, with its distinctive brown V-markings, and more strikingly three huge but harmless barrel jellyfish. Recently washed ashore, these were ice blue and pink, their extraordinary frilled 'oral arms' spread out on the sand — they are also known as dustbin-lid jellyfish, which is what these resembled in both size and shape. One species I haven't seen, but that is apparently fairly common in British waters, is the magnificent lion's mane jellyfish, with a bell that deepens to a rich crimson with age and trailing tentacles that in colder waters can grow to more than 100 feet long.

Amongst marine scientists there is a widespread idea that the changes already happening in our oceans will increasingly favour the jellyfish. Whilst unsustainable fishing practices remove many of their predators, jellies are also happy with warming seas and less affected by acidification than creatures with a calcium skeleton or shell. They can also sometimes benefit from pollution — near densely populated coasts, over-enrichment caused by run-off has already led to 'jelly blooms'. Some scientists predict oceans of the future will teem with great swarms of jellyfish.

A possible increase in their numbers here, though, has been linked to more reported sightings of two wonderful creatures that prey on them: the leatherback turtle and the ocean sunfish. Lured to our cooler waters by the jellies — which are so low in nutrients they must be eaten in vast quantities — these exotic summer visitors are occasionally seen off our western shores.

The ocean sunfish is somehow both awkward and magnificent. Growing taller than two men, it is the world's biggest bony fish. They first appeared in our seas 40 million years ago, when whales still had legs, and themselves look curiously unfinished. Their odd shape means they swim very slowly, waggling their fins like oars, which means parasites find it easy to attach. More than 40 species have been found living on them — as well as goose barnacles inside their throats — and to rid themselves of those embedded in their skin, the sunfish 'bask'.

compass jellyfish

They do this by tilting over to one side and floating at the ocean's surface, presenting themselves to the birds above and the cleaner fish below. I've seen some wonderful underwater film of this, with the sunfish like a great silver surfboard just beneath the surface, and a gull's skinny legs and great feet dancing as it tries to find balance.

These days, in their constant search for jellyfish, both the sunfish and the leatherback turtles are susceptible to a very particular kind of pollution. Discarded carrier bags in the ocean can look remarkably like jellyfish, and so are often ingested. As the sunfish breaks up the jelly by sucking it in and out of its beak-like mouth, it can easily suffocate on the bags, as do the turtles. Alternatively, as with many other marine creatures, the plastic bags can lodge in their stomachs, denying them nutrients so they slowly starve to death.

Before being discarded, these carrier bags have been used on average for about twenty minutes.

sea stars & comets

Treyarnon is another place I sometimes come after winter storms, to watch huge Atlantic rollers lash North Cornwall's cliffs and wave-riven stacks. Now though I walk out to Trethias Island at low tide, over firm seabed sand that on my last visit was beneath a churning chaos of white water, foam and wind-torn spray. In contrast, today the distant sea has left only still, sunlit tide-pools in the sand.

Many surround outcrops of the slate bedrock, and in one a spiny starfish presses itself back into a hollow. I lift it carefully and it is heavy, its stiff arms longer and thicker than my fingers. It is about the size I've found on other local beaches, but in deeper waters they are said to grow to an impressive two and a half feet.

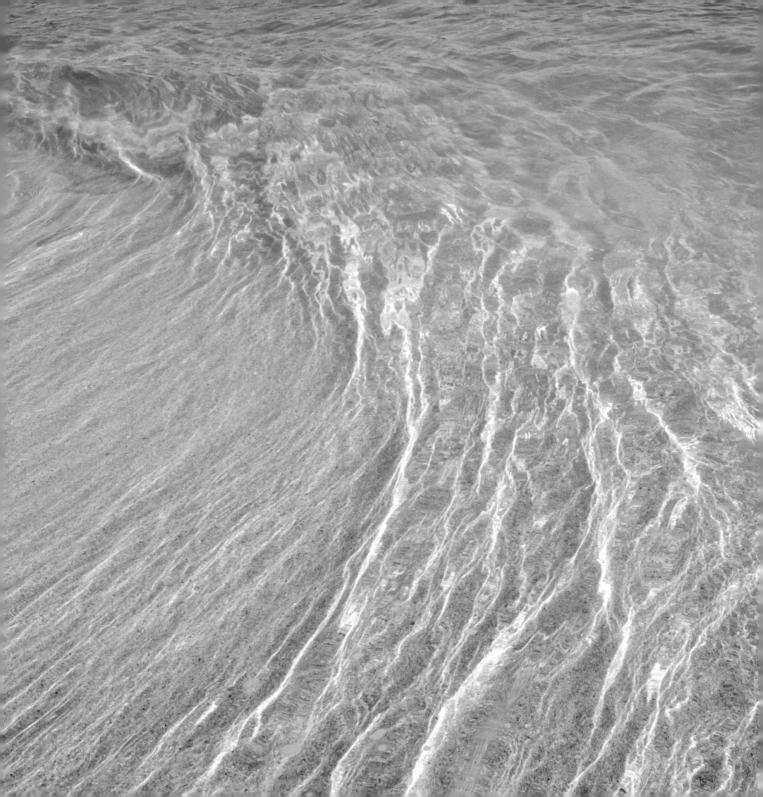

Starfish have an incredible ability to regenerate, and when I saw one recently in the process of re-growing three lost arms (below left) it took a moment to realise what it was. The arms are often detached to escape a predator – known as autotomy, which means 'self-cut' in Latin – and can take up to a year to re-grow. Incredibly, if the arm has even part of the central disc attached it is able to grow into a whole new starfish. It is often said that in the past, as starfish can decimate shellfish beds, fishermen catching them would cut them up and throw them overboard, not realising this can just increase their numbers.

There are a few species of starfish in which autotomy is unprovoked, and so is considered asexual reproduction. These either split in two across the disc – known as fission – or purposely shed a limb. The process sounds extraordinary. At first a crack appears where the starfish will split and then gradually, for up to an hour, it pulls itself apart with its own tube feet. The detached arm, which can move independently, is known as a comet (it now looks more like that than a star). Once separated, the comet initially survives solely on stored energy reserves, as it is unable to eat until it grows a new mouth.

I put my starfish back beside its hollow, suddenly concerned it might shed a limb in my hand.

above, left and centre: spiny starfish, on left regenerating three lost arms; *right:* a 'comet'

lost to the sea

I am back on the Isle of Sheppey in Kent, this time half a mile along the coast from where I grew up. The sea is flat, with the tarnished estuarine shine I remember, of sunlight on suspended silt. Against the light the shore and cliffs are drained of colour and there is the usual air of devastation here. Skeletal trees that once grew at the top of the cliff – some roots gripping its edge like knuckles – now jut from the clay at odd angles.

I come back once or twice a year, and every time am drawn to this same stretch of beach and eroding cliff – and it is always as much for what's not here as for what is. Over the years, and centuries, much along this short stretch of coast has been lost to the sea: acres of pasture and cornfield, roads, houses and gardens, farm buildings, scrapped cars and fly-tipped rubble, caravans, two churches and two pubs.

The one we went to as children was 'The Pub With No Beer'. It's no longer there, but once stood directly above where I am now, and by the time I knew it in the 1970s it was already a derelict shell, the beer garden and gents already part way to the beach. Inside it was more or less empty, but for the wreck of a piano my Nan played for 'knees-ups' in the 1940s.

They are strange landslips here. In dry weather the ground shrinks, and cracks open up, which later fill with rainwater. This then mixes with the clay to form 'slip' like that used by potters. One 1870 newspaper report describes an acre of Island land that 'slipped from its original position, and the whole mass of earth glided with slow descent down the cliff to the beach, without even disturbing the surface of the ground.' Corn has been harvested halfway down the cliff, trees have continued to grow, and on one occasion nine unhurt sheep were found on half an acre of pasture 100 feet below the cliff-top.

The erosion creates an extraordinary foreshore, which is where my fascination began. It is strewn with curiosities — natural and man-made, identifiable and mysterious — which are washed from the soft cliff during storms and high tides. The way the London clay slumps means everything washes out together here, showing no trace of the usual chronological layers of geology and archaeology. So sharks' teeth and 50 million-year-old fossils emerge alongside cutlery, kerbstones and 1950s Bakelite.

washed from the toe of the cliff

The next day, still on Sheppey, I meet Fred the Fossil Man. He mentions recent cliff falls at the far end of the Island, and says it's good for fossils now. So next morning I go with my old school friend Laurie to Warden Point, a place I haven't been in 20 years. It is no longer a point: according to erosion scientists the cliffs here lose on average five feet a year to the sea.

There is little left of the village of Warden. A hundred and fifty years ago its church stood at the edge of the cliff, closed and exposed to the weather. With the chancel already destroyed by high winds, it gradually became derelict, with locals eventually

above, from left: pyrite fossil mollusc, enamelled teapot, iron spring, fossil heart urchin, garden fork, spoon, sharks tooth; *facing page, from left*: steel toe cap, spark plug, rake, cutlery, pyrite fossil driftwood with shipworm burrows, enamelled teapot, iron curlicue, shark's tooth

taking the pews and then the pulpit for firewood. In 1876 it was demolished, and what remained — the graveyard and foundations of the church — soon went over the edge. Years later, local rumour told of an old woman who spent her days collecting the bones that washed out on the beach.

Those last decades of a Warden church coincided with the rise of the public's interest in fossils. In an 1840 edition of *The Magazine of Natural History* fossil enthusiasts were encouraged to take a trip to the Island. 'After having established yourself at your inn' it suggests the reader take the long walk to Warden, 'where the inhabitants of Mud Row work along the beach... Application should be made to know if they have any "curiosities", and very frequently excellent specimens, and at a small price, will be thus procured'.

We arrive at low tide. After a dry spell and then a weekend of unseasonably torrential rain, freshly fallen clay now slumps right out across the beach. It looks wet and still unstable, and several times there is a small and unnerving sound as a handful of drying clay trickles further down the slope. We head out onto the foreshore, staying well away from the clay.

Fred was right. Within minutes we have started to fill our pockets. Amongst the shingle and dark drifts of pyrites — that as children we raked with our fingers for sharks' teeth — we find fossil twigs and shells and palm fruits. Laurie pockets three beautifully corroded spoons, a cog and several spark plugs — we both have boxfuls of

similar oddities at home — but hands me her fish vertebrae as she already has a tinful in her shed. I pick up several fossils I haven't found before: one looks like wood with tubes twisting around and through it, and another forms a spiral. Although it looks fossil-like, I have no idea what it might be. I pocket something rather like a woodlouse and lastly what I hope might be a crab.

These London clay cliffs were laid down around 50 million years ago, a period known as the Eocene, which means 'new dawn' as it coincided with the first modern fauna. This was one of the hottest periods in the Earth's history, with palm-like plants perhaps growing all the way to Antarctica. With little or no ice at the poles, sea levels then were higher than they are today, and the cliffs above me were formed from estuarine silt laid down beneath warm, shallow seas. The fossil species found here, particularly the palms, suggest this part of Kent was a slow-moving tidal estuary, fed by great tropical rivers that ran through rainforest and mangrove swamp (it wasn't until I left the Isle of Sheppey that I discovered 'off the Island' we are known as Swampies).

The fossils commonly found here — including driftwood, molluscs, fishbones, seed pods, crabs and sharks' teeth — would initially have drifted to the sea floor, before being covered rapidly by estuarine silt. This quick burial protects them from scavengers and the usual processes of decay and erosion. Gradually, over hundreds or thousands of years, water-borne minerals 'percolate' through the sediment to replace the organism's hard parts molecule by molecule. Occasionally, where the silt's lack of oxygen prevents decay almost entirely, the soft parts are also preserved.

As the Earth is once again warming up, the predicted climate change and rising sea levels will mean an increase in the rate of erosion of these cliffs (better for fossil hunters than the people who live here). Over the coming century, the five feet a year Warden currently loses is expected to rise to ten.

The Warden church that stood at the edge of the cliff in the 19th century was not the first to be lost here. When originally built, it was said to have stood a mile inland of a much older Warden church, which in its turn 'went to the sea'. They are powerful symbols, these churches lost to the sea. As a child I was told that if you stood out on the Island's cliffs on a calm night, you might hear their bells toll beneath the waves. I've learnt since that similar legends are common to places all around the British coast, wherever erosion and rising seas have at some time in history, or prehistory, drowned villages and towns. Wales, Suffolk, the Isle of Man, Blackpool and the Isles of Scilly all have their tales of church bells that sound beneath the sea.

I go back to Fred afterwards for help identifying the fossils. It turns out I have more worms, and their beautifully curved and coiled tubes, than I realised. Those around the wood are shipworm burrows that filled with pyrite, whilst what looked rather like a woodlouse turns out to be a nautilus, edge on. The big one is, as I'd hoped, a crab — albeit a species that is common on Sheppey — and the spiral is a coprolite, or 'dung stone': probably fossilised shark poo. Fred reminds me to take care of the pyrite, or fool's gold, fossils. If not properly stored they can get pyrite disease, which is 'contagious' and causes them to disintegrate. I've found this in the past, when despite a fossil having survived millions of years in the cliff, after a short time in a damp house it can leave behind nothing but a pile of dust.

wrack

It is mid afternoon on a school day and I am ankle-deep in the shallows at Spit Beach on the South Cornwall coast, the tide rising lazily against a weed-clad reef. Wracks — spiral wrack, egg wrack, bladderwrack, saw wrack — have hardened to black in the midday sun, and filmy sheets of purple laver, that smothered rocks as the tide ebbed, have shrunk and stuck fast. If this were anywhere but the shore, you would think they were dead.

I wait, and as the water reaches the weed it is brought, miraculously, to life. The laver lifts from the rocks and unfurls. Shrivelled bladderwrack rises with the tide, the bladders holding it up in sunlit waters as it softens, taking on the olive-greens of its youth.

In what seems no time at all, the water has risen to the tops of my boots. It is clear as glass. All around me seaweed reaches up for the light, its rich greens and browns graceful in the gentle swell. An hour ago it seemed barren here, now I am standing in a sunlit garden. As if magically, all the life of the shallows is back too: glassy shrimps, a shoal of tiny silver fish that slip amongst the weed or hang motionless, darting for cover when I move.

But, as has happened before, it beguiles me and I stay just a little too long. One boot and then the other fills with water. I tip it out, but there isn't time to go back and change. It won't be the first time I've had to walk past the waiting parents at school with the unmistakable — and surprisingly audible — squelch of wet socks inside rubber boots.

AUGUST

grains of sand

The tide has turned and is on its way in. The children run on ahead of me in their pants, down the beach and out across wet sand to distant surf. The sea is turquoise inshore and deep blue to the horizon; in the shallows, with the cross-shore breeze, the Atlantic waves collapse into foaming white water. Although the children are way out now they are barely waist-deep, and as each wave crumbles around them they jump and are swallowed, disappearing briefly before re-emerging, exhilarated, nearby — now and then clutching their pants.

right: saw, serrated or toothed wrack as the tide returns

play of light in the shallows at low tide

I roll up my jeans and wade out into the shallows with my camera. Unlike further out, the waves here are gentle, running in over sun-warmed sand. Ankle-deep, the warmth of the water is delicious. Now and then, in a rush of new cold, a wave rises around my calves and then retreats, not mixing at once but leaving fingers of warmth in its wake.

After weeks of quiet summer weather the water is clear as glass. Below, refracted by its lens-like surface, sunlight ripples in waves across the seabed sand. Where the water is shallowest — over gentle banks and ridges — tiny glassy waves form, lining up to chase each other in. I follow them through the camera's lens but they are fleeting, already vanishing and never quite repeated. The tide moves on, taking with it its patterns of light; where I stood ten minutes ago is already taken back by the sea.

As always, through the slight close-up of the lens, the sand's seemingly uniform golden-tan reveals itself to be an extraordinary variety of colours, and the closer I look the more I see. To go further and view it through a microscope gives some idea of the true beauty and variety of sand, and perhaps something of the story each of these grains has to tell.

There are two types of grain that make up sand. Mineral sand is formed from rocks through a process of erosion, and biogenic grains are the remains of once-living organisms. By far the majority of sand comes from granite, a hard, resistant rock that breaks down into grains of quartz, feldspar and hornblende, along with the shiny flakes of mica that can give sand its glitter. Some of the most striking mineral grains are tiny gemstones — such as garnet, topaz or amethyst — their crystal forms ground and polished by the waves.

A grain's roundedness gives an indication of its age, and possibly how far it has travelled. A smooth, well-rounded grain of quartz may well have broken away from its

parent rock hundreds of millions of years ago, and may have survived repeated cycles of erosion and compression, for example into sandstone. Angular mineral grains are likely to be younger, and often more local.

Under the microscope, the most sculptural and beautiful of the sand grains are biogenic: minute, waveworn fragments of the shells and skeletons of creatures both familiar and strange. I have a copy of the book *A Grain of Sand* by Gary Greenberg and his photographs of these biogenic grains, taken through a powerful microscope, are captivating.

Some of my favourites are from sea urchins. There are minute remnants of baby urchin shell, delicately coloured and patterned with circles, worn so thin they are now translucent. The fragments of urchin spines are intricate green or purple rods, often beautifully rounded, and running through the centre of each — like a stick of rock — is a perfect mandala.

There are also remnants of corals, grain-sized pieces of mother-of-pearl, and the beautifully eroded fragments of tiny shells, with just the sea-worn traces of their original forms: spirals perhaps, or radial ribs and grooves. I also love the sponge spicules (above): glassy, needle-like structures that give sponges their shape and strength. Often 3-, 4- or 5-pronged, they can also be shaped like fishhooks or hairpins, spiders, even anchors, and are how scientists confirm a sponge's species.

For me though, the best sand grains are the foraminifera (below), which means 'hole bearers'. These were once the intricate shell-houses of microscopic creatures that live either in the plankton or on the sea floor. There are thousands of species, both living and extinct, and whilst their chalky skeletons appear fragile, incredibly many survive the ravages of the waves and abrasion of the sand in almost perfect condition. Under a microscope they are often beautifully rounded, their wave-polished forms at times with the texture of porcelain.

The sand here, shifting beneath my feet with the swash and backwash of the waves, is for me — without a microscope or an expert to hand — a mystery. There are quartz grains, definitely, and mica, and the black flecks are probably magnetite (it turns out you can check this with a magnet). There will no doubt be slate from local bedrock, and possibly grains of greenstone or serpentine, carried by the tide from further west. There may also be brilliantly coloured gemstones. Agate, topaz, jasper, opal and amethyst are all found in Cornwall, even tiny amounts of gold.

There will be grain-sized fragments from the skeletons of the creatures that live in these waters: the sea urchins and sponges, sea mats and starfish, and the hundreds of species of mollusc, lobster and crab. There will also be beautiful foraminifera. For someone who can read it, a handful of this sand can provide a fascinating geological and biological history of this whole stretch of coast.

left: sponge spicules; *above*: foraminifera

sea gooseberry's 'fishing net' tentacles

sea gooseberry
washed up on the sand

After half an hour the children are out of the sea, skinny and freezing, running over to a series of shallow pools in the sand. The water here, in depressions left by the tide, has lain all day in the sun and is warm as bathwater. They lie in them, low as they can for the warmth, wriggling their bodies down into the sand like flatfish.

sea gooseberry

Just ahead of me the gentle incoming tide pushes something transparent a little further up the beach, then leaves it stranded on the sand. It is small and jelly-like, a little collapsed, and I think at first it is a small moon jelly. I pick it up and it is barely there in my palm, transparent, almost weightless, and as it regains its form I realise what it is — a sea gooseberry, the first one I've ever found.

They are not jellyfish, but unrelated 'comb jellies'. Close-to I can see its near transparent 'combs', rows of cilia that beat rhythmically to propel it through the water. It is these that in life give comb jellies their striking beauty. As they beat, the cilia refract light, shimmering with iridescence so pulses of coloured light run the length of their transparent bodies. They are also said to be phosphorescent (or more correctly, bioluminescent) as other comb jellies are, shimmering with blue light after dark.

Although seemingly fragile they are voracious predators and can eat up to ten times their own body-weight a day, which often includes other sea gooseberries. Two long feathery tentacles act as sticky fishing nets and the ensnared prey is 'reeled in' to the comb jelly's mouth.

When I put this one in a nearby rockpool it slowly sinks and all but disappears. There is no movement, no shimmering light show. As with the jellyfish, soon after a sea gooseberry spawns, it dies, so this form is only found in the warmer months.

sea fire & luminous lures

I was about 11 when I first saw phosphorescence. I was staying at a friend's house on the Isle of Sheppey, and after some persuasion her dad woke us at 3am and took us with him to check the fishing nets he'd set on the last low tide. It was a warm summer night and as we waded out into dark shallows trails of blue-green light flared in the wake of our legs. It was extraordinary — cold, magical flames that went out as soon as we'd passed.

Since then I've heard others tell of phosphorescence with similar wonder: trails of light as oars move through dark water, of night-swimming with it, of waves lit from within as they break. The mysterious light is also known as sea fire or sea ghost, and in the past sailors believed it to be 'the hand of Poseidon', a sign from this god of the sea. In Orkney folklore phosphorescence lit the homes of the Finfolk, dark 'shapeshifters of the sea' that kidnapped fishermen near shore and took them down to their eerily lit halls, into lifelong servitude as a spouse.

This sea fire is produced by plankton blooms, in particular a single-celled dinoflagellate that emits tiny sparks of light when disturbed. The blooms are more likely during warm weather, and the phosphorescence brightest after prolonged sunshine the previous day (although the plankton are not merely storing the sun's energy as with fluorescence). When the plankton sense movement in the water a chemical reaction takes place in tiny organs known as 'scintillons', which emit the heatless light. It is thought its purpose is to draw attention to an approaching predator, rather like a burglar alarm, and in doing so attract larger predators to attack it.

Bioluminescence is used by a wide range of marine creatures across all major groups (phyla) and has been described as 'a silent language of the sea'. It is found throughout all parts of the ocean and is believed to have evolved separately at least 40 times, implying it is both important and relatively simple. The light is usually

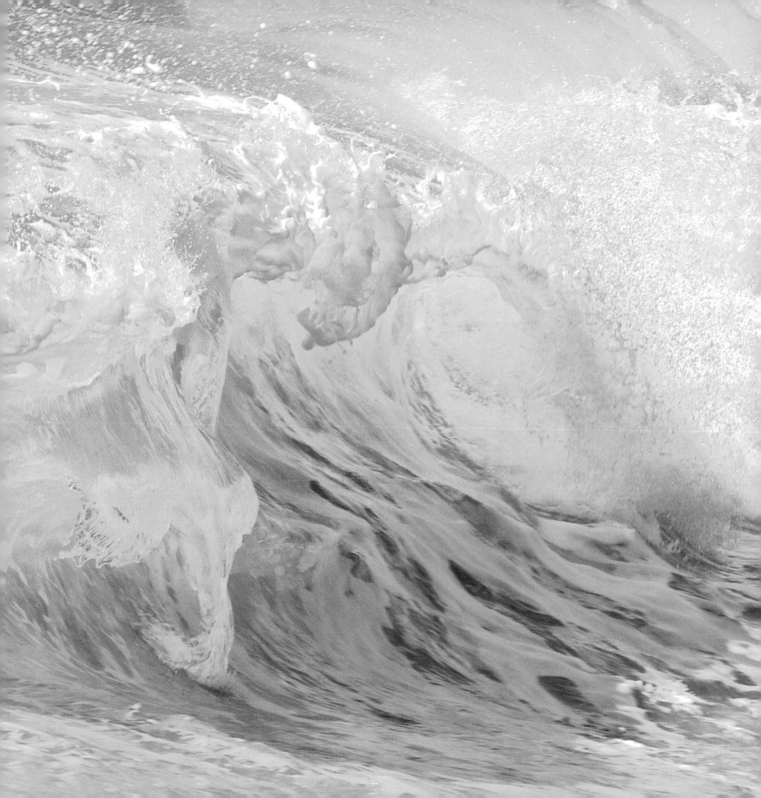

blue-green, as this wavelength travels most easily through seawater, and it is put to a remarkable variety of uses.

It is most commonly seen as a defence, used to repel or distract a predator. Some squid will emit a cloud of bioluminescent ink and then go dark to escape. Another extraordinary technique — used by some brittlestars, squid and worms — is that of bioluminescent 'distractive body parts'. A brittlestar, for example, is able to detach one of its glowing arms before it goes dark, crawling away as its predator pursues the separated, but still glowing — and often twitching — arm. Occasionally the luminous body part is detached onto the predator and in doing so becomes what is known as a 'sacrificial tag'. Either attached directly, or maybe glowing inside the stomach of a translucent body, it then attracts larger secondary predators to the first.

It is uncommon for molluscs to be bioluminescent, but there is one found on the south coast of Britain: the common piddock I glimpsed in holes in the otter sandstone. These elegant clams were once eaten raw, most notoriously by the Romans, and Pliny the Elder writes of them in his *Natural History* of 77 AD: '...piddocks, which shine as if with fire in dark places, even in the mouth of persons eating them.'

One of the most well-known uses of bioluminescence is by anglerfish in the dark waters of the abyss. They are named for their fleshy 'lure', usually at the end of a filament that resembles a fishing rod. Britain's most commonly caught anglerfish is sold at the fishmongers as monkfish, although as it lives in shallower waters it has no need for its lure to be luminous. There is a remarkable group of anglerfish that do, though — the seadevils — and their names are almost as wonderful as their forms. The lures of the triplewart seadevil, the wolftrap and the whalehead dreamer are all packed with symbiotic, bioluminescent bacteria.

What is less well known is that the anglerfish with the bioluminescent lures are always female, and it was a long

warty seadevil: female with tiny parasitic males attached

black seadevil

time before we understood why. Initially the males were never found, until it turned out seadevils exhibit what is known as 'extreme sexual dimorphism', with the males up to 40 times smaller than the females. Protrusions that were initially thought to be some kind of extra fin turned out to be the males.

Deep in the cold abyssal waters the young free-swimming male anglerfish has huge nostrils and eyes to help in his search for a relatively gigiantic mate. Known as a 'lurk and lure' predator, she is shaped to remain motionless for much of the time. In such dark and barren depths he will come across a female only rarely, so for when he does, he has evolved to never let her go.

In an almost unbelievable process the male uses specialised 'teeth' to pierce her skin and latch onto her. As soon as this happens his jaw begins to fuse with her skin, in a process that is little understood. She then begins to absorb him, gradually, until their bloodstreams fuse and he begins to degenerate. He loses his eyes, as they are no longer needed, and all his internal organs. His testes, though, begin to grow. Once the process is complete he remains attached to her side for the rest of his life, as little more than a pair of testes producing sperm on demand until she dies. Whilst some species of seadevil are monogamous, there are others where the female may collect up to eight of these parasitic males during her lifetime.

SEPTEMBER

endings

Now September is here eight in the morning feels early again. For days now there have been clear skies and not a breath of wind, and the quality of the air has changed. Softened by the slightest of mists, it has a lustre that holds the first smell

115

of autumn. It is also the first day of the new term. Ten minutes ago I dropped my son at the bus stop for the first time, the long summer holiday over, for his first day of secondary school. In Cornwall this has been the only long, warm summer for years — the one the children remember — and I wonder if it might be their summer of '76.

On the way home I stop in Talland at Stinkers, a strip of beach named not — as I'd always imagined — for the great heaps of seaweed thrown up during storms, but from a Dutch word for 'stony'. Today though, the gentle tide has left little. Scraps of drying seaweed are scattered in a meandering line across the beach, high on shore as tonight is the harvest moon, the full moon closest to the autumn equinox. I follow the seaweed trail, mainly Irish moss and other reds I'd struggle to name, half in sun and half in the shadow of the cliff. In shade they are still damp with the night air and the sea, but where they lie in sun are just beginning to tighten and curl.

Red seaweeds get their colour from red and blue accessory pigments, which mask the chlorophyll and allow them to capture the sunlight that travels deepest in seawater. This means they can live at greater depths than the others, the greens and the browns. Exposed to light, though — as these are now on shore — the pigments soon begin to break down. The weed's rich reds and purples fade, through shades of mauve and old rose to a creamy, translucent white. Close-to, some are also delicately patterned with the lacy remains of sea mats and firs, and the pink blossom of coralline algae. I collect them, some softer, some spikier in my palm, although I know from experience they won't last in this half-state.

I breathe this new autumn air, wonder about my son on the bus. For me the stillness of these past days and nights has lent them a strange fragility. We are suspended, waiting for something to end. I catch myself thinking maybe next year the children will be too old to run down the beach in their pants.

red seaweeds, some losing their colour as the pigments that allow them to live in deeper water break down
fossil records suggest this ancient group has been around for 1.2 billion years

wine moon, singing moon

That night I drive back to the same beach to see the moon. A striking full moon anyway, this year's harvest moon — known also as the wine moon or singing moon — is at the perigee of its orbit, and so the closest it comes to the Earth. A supermoon, they've been calling it on the radio.

The sun is a bloody orange on the horizon as I drop down into the shadow of the valley. Then from the beach I climb on foot, a steep track worn a little inland of the old, which since the winter storms runs too close to the edge. By the top I am already losing the light. I stop. It is warm and still, the air full of the sound of crickets; up ahead a rabbit hops lazily away. Way below though, the moon-drawn tide presses up against the land, unusually high beneath this closest of moons.

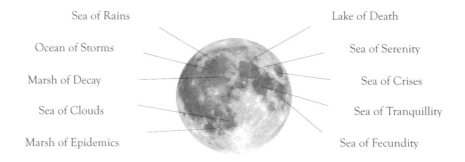

Sea of Rains — Lake of Death

Ocean of Storms — Sea of Serenity

Marsh of Decay — Sea of Crises

Sea of Clouds — Sea of Tranquillity

Marsh of Epidemics — Sea of Fecundity

Although I know the moon has risen by now, I haven't seen it. I keep walking east, a mile, maybe two as the light seeps steadily away. It's further than I intended, as each headland I round reveals nothing but the dark outline of the next. And then at last the path climbs steeply and there it is. The moon! I grin, despite expecting it. It hangs above the black outline of the cliff, rose-gold, huge and fantastical.

For perhaps billions of years now, the moon has been 'tidally locked' to the Earth, and so has kept this same familiar face turned towards us. Its features — the spectral highlands and the shadowy craters once presumed to be lunar seas — have retained the evocative names given them by an Italian priest in the 17th century. The eyes of the 'face' we perceive in Western Europe are the Sea of Rains and the Sea of Serenity, its mouth the Sea of Clouds. An older European tradition sees instead the figure of a man — the Seas of Serenity, Tranquillity and Fecundity — carrying the Lake of Dreams on his back and accompanied by a dog, the Sea of Crises. Named for the 'effects and influences' of the moon, there is also a Marsh of Decay and a Marsh of Epidemics, a Lake of Death and an Ocean of Storms.

The moon is steeped in myth and superstition, as for millennia human societies have looked up and wondered at its powers. If it can influence the oceans, and animal behaviour and fertility, what effects might it have on us? Phases of the moon — in particular the full moon — have long been linked to increases in human violence and mental instability (the word lunatic is from the Latin for moonstruck). In the past a number of scientific studies have suggested a correlation with increases in crime, murder and suicide rates, and in hospital and psychiatric admissions. As recently as 1952 a Cornish burglar was acquitted when the judge accepted the man's plea of 'moon madness'.

In the main, though, the reports of a 'lunar effect' on our own behaviour are not supported by evidence. On closer scrutiny the majority turn out to be anecdotal, unreliable or impossible to replicate. But we continue to look. It is not what we want to hear. The stories and the old beliefs linger, are too deep a part of our mythology — we cannot strip the moon of its mystery. Which is perhaps why science has kept the old names of the lunar 'seas'. As the science writer and astronomer David Whitehouse says in his *The Moon, a biography*, it is 'forever beyond the reach of science.'

I turn back. The darkness and the landscape close in around me, the moon not high enough yet to give light. By halfway back, I can barely make out the paler trodden dirt of the track. This lends an intensity to everything, along with the height of the cliff and unease of the sea on the rocks below. The path veers in from the edge, and teasels and wind-stunted gorse stand in silhouette against the shine of the sea. Whiteness catches my eye: tufts of thistledown, the pale flicker of moths. There is still not a breath of wind, just the summer night-smell of dry earth as its warmth is released. In the distance an owl calls. Then, spooked by a scuffling close-by in the undergrowth, I pick up my pace towards the next headland, its pinpricks of electric light like stars.

Late that night I stand at the bedroom window and turn off the light. With its plastic click the shining reflection of a room vanishes, and the night outside is revealed. As it has before, the cold, other-worldly light of the full moon takes me by surprise. It is high in the sky now, and beyond the glass the trees and unkempt hedges stand stock still and drained of their colour. A black edge of roof-shadow cuts the lawn in half. It is not the garden I know. It is a stage set, for puppets perhaps — with the light on I had no idea it was out there.

OCTOBER

mussels & sea silk

It is a couple of days after the full October moon — this the hunter's or blood moon — and so another big spring tide. Here at Holywell Bay, as in all of South West England, the low spring tides are always in the middle of the day, and as I walk out onto wet sand the tide is almost on the turn.

The air is still and mist veils the tops of the cliffs and the twin islands just offshore. Known as Gull Rocks, or by others as Fish Tail Rocks, together they resemble the

crowded mussel beds on exposed Atlantic shore

flukes of a diving whale, although with the Atlantic waves filling the air with spray at times they are barely there at all.

From shore I can see a dark shape at the water's edge and set out towards it, thinking it might be a stranded dolphin, perhaps even a whale — at this distance I have little sense of scale. I'm a long way from shore before I make out what it is: the remains of a wrecked ship, shaggy with wrack and crowded with mussels. Part-buried in the sand is the curve of the prow, and a few rusted stumps mark the hull and stern. I learn later it sank in 1917, almost a century ago. Now, though — like so many similar wrecks in Cornish waters — it is a reef, a rare stability out here on these shifting sands, and every inch above the first sand-scoured foot has been colonised.

Slack water has passed, though, the tide already turned, and before long the sea is taking back what it so briefly revealed. As powerful Atlantic waves surge back in over the wreck, soon submerging it, it is hard to believe the mussels could survive out there. The more exposed a coast is, though, and the wilder its surf, the greater the mussels' advantage. Little else can hold on — not the tough wracks and barnacles in competition, nor the predators — so the mussels dominate, crowding together in dense beds.

Their secret is byssus threads, a kind of natural silk spun by a gland in the mussel's foot — the 'beards' removed before cooking — and it is put to a wonderful variety of uses. The juvenile mussel uses its early thread for buoyancy, as it drifts through the ocean in search of a place to settle. Then once it finds somewhere, it uses them rather like climbing ropes, attaching and pulling itself along until it finds the right spot.

Once satisfied, the mussel sends out its silken anchor lines in all directions, securing them to the rock with a drop of exceptionally strong glue. The strength of the glue and threads alone, though, is not enough to account for the extreme forces mussels

dog whelk drilling through a mussel shell, with byssus threads visible below

are able to withstand. It turns out it is the byssus threads' precise mix of stiff and elastic parts that is crucial, meaning it works like a beautifully designed bungee cord. Its 'give' allows the waves to pull the mussel out from the rock a little, but not too far, and this lessens the force of the impact.

Byssus threads are produced by a number of related species too, including the fan mussels or pen shells. Whilst fan mussels are found in these cool Cornish waters — although scarce now, with their fragile up-standing shells easily damaged by trawls and dredges — it is their much larger Mediterranean relative, the noble pen shell, that is famous for its thread. In the past this was woven into a fine golden cloth known as byssus cloth or sea silk, and traded in ancient China as mermaid silk. Due to its rarity and value it was worn by emperors, pharaohs and kings, although today — with the noble pen shell endangered — the industry has died out.

At times in the past though, fan mussels caught by fishermen were thrown back, considered unclean as the threads' likeness to human hair had led to a belief that the mussels fed on the drowned.

The byssus threads of our common blue mussel are also put to another intriguing use. A major mollusc predator is the dog whelk, and it is quite common to find a mussel shell washed ashore with its tell-tale signature: a small and perfect hole drilled through it. In its attack the dog whelk (previous page) glides up onto the mussel and, after weakening its shell with acid, uses its radula — a scythe-toothed tongue — to drill its way through. It is a slow process and takes days, until at last the whelk sucks the mussel out through the hole like soup.

Wonderfully, though, when the mussel's neighbours sense an attack, they launch their defence. Spinning new byssus threads, they throw them like ropes over the dog whelk, tethering it to the rock or its prey. Sometimes the whelk is overturned by this, saving the life of the mussel — but often it isn't. In these cases, although the whelk is

free to finish its meal, it will be its last. Trapped by the threads, and unable to move and so to feed, it either starves to death or becomes prey in its turn.

I return early the next morning at high tide. The mist has lifted with the offshore wind and above the islands a break in the cloud reveals a pale, no-longer-full moon: 'gibbous', from the Latin for hunch-backed. The waves are wilder than yesterday's, crashing high on the deserted shore and marbling the sea with foam.

Along the strandline a drift of blue mussel shells has been left by the tide in the night. Some are huge, much larger than the ones I usually find, and than those crowding the rocks here and the wreck. As filter feeders, mussels have longer to feed if not uncovered at low tide, so grow larger offshore. Maybe these are from out by the islands.

dulse

mussel shells with

keelworm

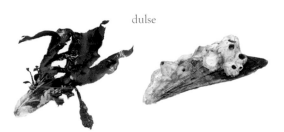

and

acorn barnacles

Some of those on the sand have been recently torn free and are still shut tight. Although it is possible for a mussel to spin new threads and reattach itself, it is rare; more often they wash ashore as these have. Quite a few I pick up are festooned with seaweeds, some gripped by the holdfasts of young kelps and trailing their stipes. I recognise oarweed and furbelows on some, as well as dulse and what I think is purple laver. Several are enamelled with pink paint or fringed with tufts of coral weed; on others I find barnacles and sea mats, and the white scrawl of keelworm tubes.

127

I learn later that in Britain our blue mussel beds support at least 133 other species. So these mussel shells at my feet are clues, a glimpse of rich ecosystems out there beyond the waves, and of the extraordinary ways creatures living there have had to evolve in order to survive.

earth days & lunar months

It seems that once, in the deep past, the moon appeared much larger in our skies than it does today, as it was once much closer. Currently, the favoured theory is that the moon formed around 4.5bn years ago, the result of a massive impact between the Earth and a Mars-sized planet, and ever since has been moving slowly but steadily away from us. As this increases the size of its orbit, our months gradually grow longer; in a related effect the Earth spins ever more slowly, and this lengthens our days.

Beautifully, evidence supporting this can be found in the skeletons and shells of some marine creatures. Corals, for example, deposit their calcium skeletons daily, and their growth rates are affected by temperature and light. This means that under a microscope both annual bands and fine daily ridges can be visible, preserving a record of the number of days in a year during its lifetime. Fortunately, corals have been around for hundreds of millions of years and preserve well as fossils, and studies show that the further back we go in time, the greater the number of daily ridges between annual bands. Which implies that in the past our Earth days were shorter. Corals that lived 370 million years ago, for example, show an average of 400 days in a year, and so a day 22 hours long.

The chambered nautilus too lays down its spiral shell daily as it grows. In addition, periodically it moves into a new, larger chamber and seals off the old with a wall (the empty chambers are then used for buoyancy). Our modern nautilus shows

an average of 29 fine ribs between its walls, suggesting they correspond to the 29 days in a current lunar month. As with corals, species of nautilus have lived in our oceans for hundreds of millions of years and fossilise well – and palaeontologists find that the further back we go in time, the fewer ribs there are between walls. For example, nautiloids that lived 450 million years ago show on average nine ribs per chamber, suggesting that back then the lunar month lasted only nine days.

These findings support evidence from a variety of other sources: certain sandstones and stromatolites (from the Greek for 'mattress rock'), as well as mathematical models and – since 1969 – lasers bounced off the moon. The latter show that at present the moon is moving away from us by 3.8 centimetres a year, about the rate our fingernails grow. And, as the models predict, our days continue to lengthen. Since 1972 atomic clocks have had 25 'leap seconds' added.

The cause, it seems, is the Earth's tides. The drag of the 'tidal bulge' – where the ocean is drawn towards the moon – causes both the Earth to slow down and the moon to speed up. Like on a carousel, this means the moon is sent spinning ever further away.

So those oceans the nautiloids dominated 450 million years ago would have been very different to ours. With the moon less than half its current distance from Earth, it would have appeared more than twice the size in the sky, racing through its phases – new, crescent, quarter, gibbous, full, then waning through to new again – in only nine days. That close, its effect on the tides would have been huge, with not just a much greater change from day to day but also a more extreme tidal range. For the trilobites, starfish, sponges and brittlestars that inhabited the shores of those warm Ordovician oceans, high tides would have been much higher and the lows much lower.

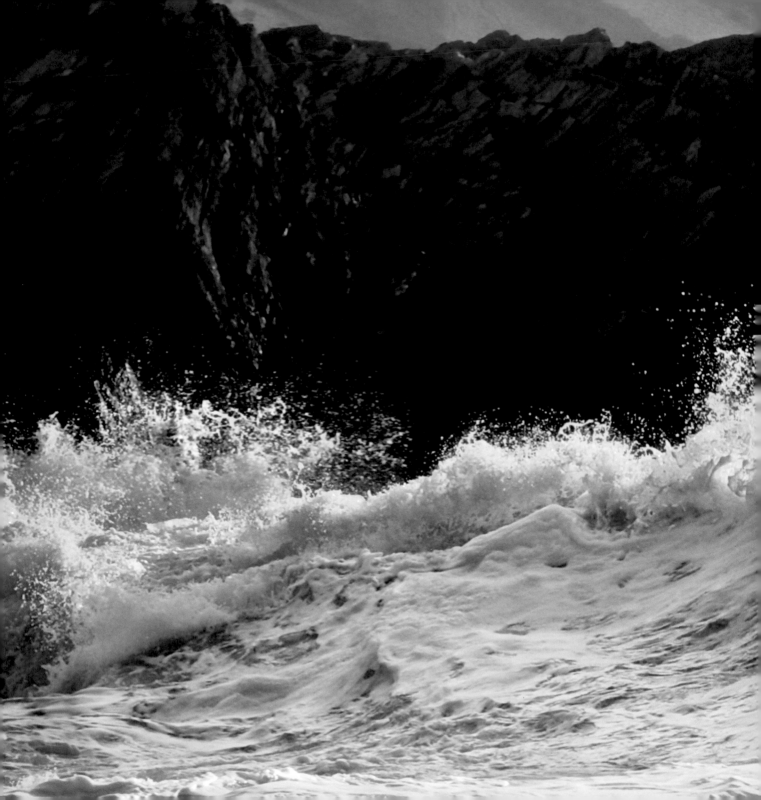

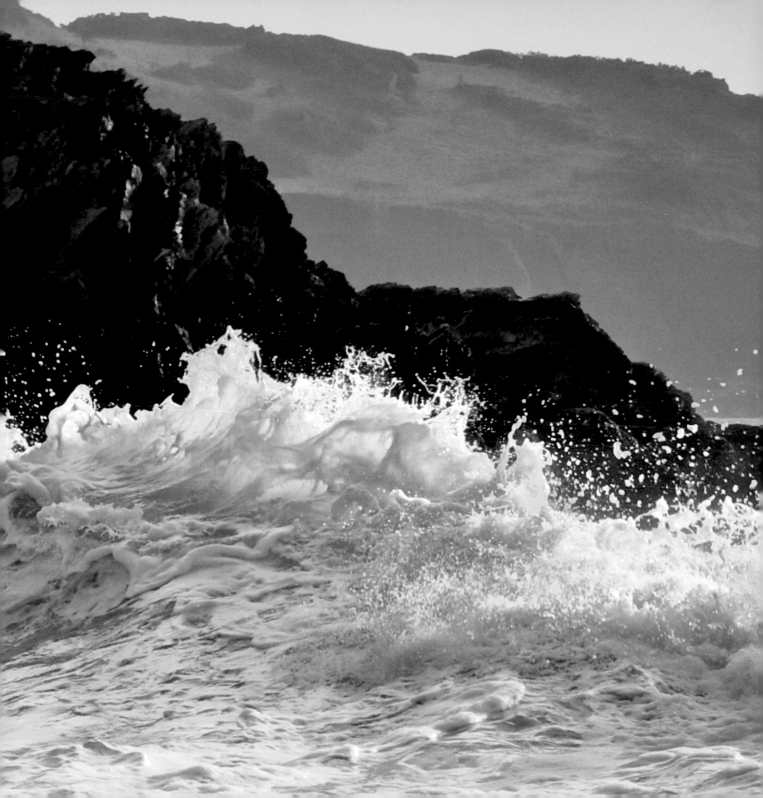

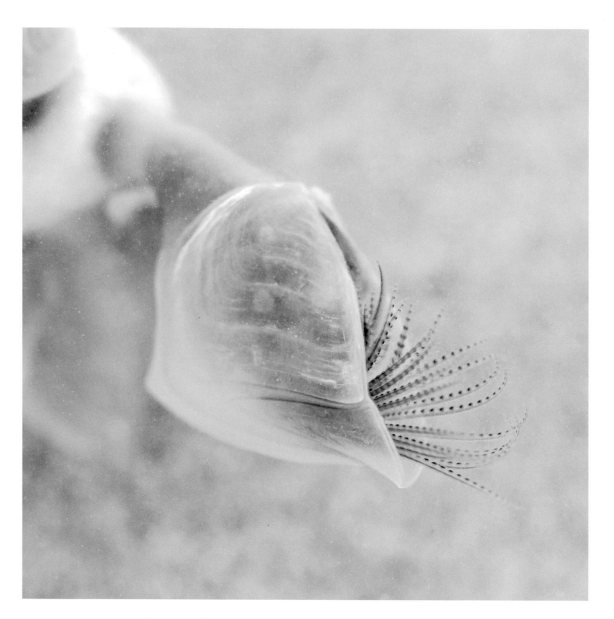

buoy barnacle extending feather-like legs to sweep the water for food

buoy barnacles

A day after westerly gales, the children and I stay the night at a youth hostel on Cornwall's north coast. When we arrive the sea is wild and white, the waves still rolling in relentlessly, and before checking in we cross the headland to the beach at Constantine. With the tide on its way out, I leave the children playing by rockpools and head out along the strandline towards Booby's Bay.

Amongst the seaweed I find first a triggerfish, and then a feather with four beautiful buoy barnacles attached to it. This time I know what they are — I found my first a month ago, attached to a strand of egg wrack, and went home to look them up. It turns out they are a kind of stalked or 'goose-neck' barnacle that spends its life on the open ocean, similar to a more common species that washes up on this coast fairly often. These are unusual though, in that they secrete their own airy cement 'buoy', which allows them to float, and therefore feed, at the water's surface. In his 1851 monograph on the barnacle, Darwin devotes eight detailed pages to their anatomy, describing the buoy as a 'beautiful and unique contrivance'.

Looking rather like a bead of expanding foam, a single buoy is often shared by several individual barnacles. It can be attached to other flotsam as well — as with the feather — which can be almost anything that floats: buoy barnacles have been found on cuttlebones, driftwood, plastic debris, turtles, even the tar balls from oil spills.

I find four more feathers-with-barnacles and take them back to show the children. We lay them on the surface of a rockpool and, wonderfully, one group is still alive. As soon as they touch water, the beautifully formed translucent plates open and delicate legs emerge, unfurling to sweep the water for food. The children hold the feather still as I watch through the close-up of the lens. The movements are rhythmic, mesmerising, and now and then a barnacle slowly and gracefully bends its goose-neck — or, more accurately, its peduncle.

Later on, when we check in at the youth hostel, I am uncertain what to do with the triggerfish. After much deliberation — too smelly to be left in the car or room, might get eaten if under the car all night — we put it inside the engine, and my son writes FISH in the bonnet's dirt to remind us before we drive off.

no sign of a whale

I stop in a lay-by on a stretch of cliff-top road near Rame Head, a headland separating Cornwall from Devon, and get out to photograph the sea. Over the years I've taken hundreds of these pictures — empty horizon, half sea, half sky — and it isn't often like this. The weather is moving in fast on an onshore wind but the sun is still out; beneath the darkening sky the sea is so pale it seems to be the source of the light.

It was from here that a friend saw a whale, and it was wonderful just to hear about it. Late last summer she was up on the cliff with a fisherman. It was early evening, the sea flat — 'milky' she called it, after a long hot day — and the first they saw were shadows at the surface. Mackerel, they

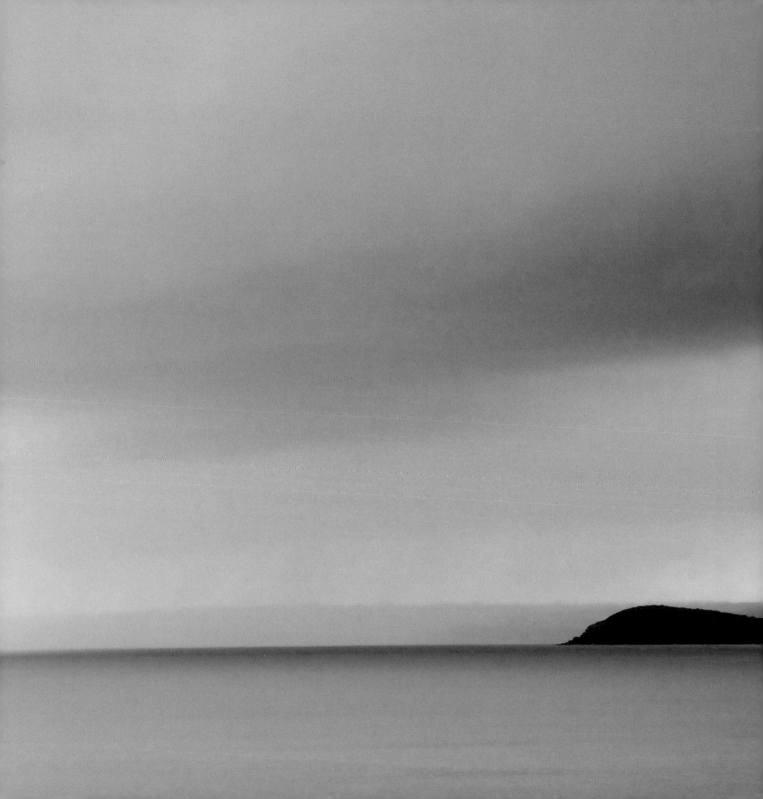

guessed. Then they saw a fin. Perhaps a dolphin, then. But it seemed to be moving so slowly. It wasn't until a local boat approached that they had any sense of scale: they knew it to be a 30-footer, and the shadow was as long as the boat.

Although largely unseen, there are many species of whale that pass through British waters. The one they saw from here was probably a minke or pilot whale, and both

ambulocetus
50 million years ago
10 feet

rhodocetus
45 million years ago
10 feet

of these are reasonably common off our western shores. In the deeper waters off Scotland's Hebrides and Northern Isles though, closer to the edge of the continental shelf, there are also regular sightings of the larger, more iconic whales: humpbacks and sperm whales, even — just occasionally — a blue whale.

I continue to stare out. Now the weather is here the light is no longer extraordinary. The sea shines back at me — no shadows, its surface unbroken — giving nothing away. There is no sign of a whale. With the first spots of rain I get back in the car.

I have been reading about whales. The story of their evolution is wonderful, creatures that moved from the sea onto land and then back again. And in this return to the sea — an evolutionary reversal — they began to lose the adaptations they had acquired to live on land. With the last of the walking whales, the fins that became legs now became flippers. The anatomy of modern whales supports the fragmentary fossil evidence, as in the womb embryonic whales show traces of their terrestrial ancestry — at first they have nostrils instead of blowholes, hair, and the buds of their lost hind limbs.

Back in the sea, the early whales' mammalian ears also proved useless — underwater they were unable to detect a sound's direction — and some of the most interesting of the intermediate whale fossils are the ear bones. Around 45 million years ago, with their legs now adapted for swimming, some of the early whales show features of both systems: the old terrestrial ear and that used by modern whales today. Five million years on, another group had evolved — massive snake-like whales that had tiny residual hind limbs and were unable to leave the water. In these the old mammalian ear had all but disappeared, and like today's whales they heard through their jaw.

It is the magnificent, blunt-headed sperm whale — the most ancient of the modern whales — that has the most impressive system for producing and receiving sound. In mature males the nose, effectively a huge amplifier, makes up an incredible one-

basilosaurus
40 million years ago
65 feet

sperm whale
65 feet

humpback whale
50 feet

third of the whale's entire body size, producing sounds that can be heard many miles away. Famous for their battles with the giant squid sometimes found in their stomachs, sperm whales hunt at great depths in near-total darkness, and like bats use sonar clicks to 'see' their prey in sound. Along with these foraging clicks and communicating 'codas', they also emit 'creaks' as they home in on prey, and mature males produce a lower, more mysterious 'clang' that may be heard by whales 40 miles away.

Sound is produced in the sperm whale's nose as air is forced through a valve known as the 'monkey's muzzle' and then passes through the 'case', the first of two oil-filled reservoirs. It then bounces off a bony sound mirror before entering a second reservoir known as the melon ('junk' to a whaler) where a series of acoustic lenses allow the whale to focus, and so aim, the pulse.

In the 18th and 19th centuries it was for the waxy spermaceti oil in these reservoirs that sperm whales were hunted to near extinction. This valuable, almost magical oil was used to light streetlamps and turned into high quality candles, and it wasn't until the advent of petroleum, gas and electricity that its popularity — and so the killing of the whales — began to wane.

The strange sounds the whales made, often heard through the hulls of whaling ships, were once thought to be ghosts in the sea. Of all whale song the most haunting and beautiful, as well as the most complex, is the 'long song' of the male humpback, which can also be heard many miles away. Underwater recordings reveal the structure of their songs echoes our own, with repeated phrases strung together in themes in a particular order. They are sung in the breeding season, although it is not known if this is primarily to attract females or threaten rival males.

Some of the most surprising findings are from longer-term research. At any one time all males in a humpback population will be singing the same song: a repeated series of long groans, roars, trills and chirps that may last a quarter of an hour. Over time the song changes, but — incredibly — all males in a population will make the same changes. So a few years later the song may be entirely different, but all the males in the group will be singing the new song.

The rain strengthens, and through the windscreen the silver sky runs into the sea. I stay on though, thinking about whales, drawn like so many of us to look out to an empty horizon.

NOVEMBER

plastic

A week later I am sent a list. A friend organised a beach clean of a Cornish cove I know, and volunteers have now counted every piece of plastic they found that day.

It includes: 55 balloon pieces, 16 toothbrushes, 156 lighters, 24 golf tees, 33 paintbrush handles, 25 shoes, 7 baseball cap visors, 16 pieces of plastic cutlery, 2768 bottle tops, 30 toy soldiers, 10 dummies, 17 combs, 44 plastic bottles, 4 tampon applicators, 1310 cotton bud sticks, 61 gun cartridge cases, 847 pieces of polystyrene, 20 Smartie lids, 42 pieces of Lego, 500 pieces of rope and net, 3 plastic moustaches, a toilet seat and 401,230 nurdles, the bead-like raw material of plastic.

For me this is a powerful list, and not just because I regularly see all these things along the strandline — perhaps not moustaches — and know how dangerous they can be to marine life. Not all have been left behind on the beach or thrown from a boat: there is more to it than that. The majority are things we've all bought and at some point discarded. It is a deeply disturbing reminder that unless we take more care in what we buy, and what materials those things are made from, then nothing will change.

squall
from the Old Norse, meaning 'to cry out'

Out on a low headland in North Cornwall I watch wave after wave power into Trethias Island across the bay. It faces west here, and there is nothing ahead but thousands of miles of open water. With strong onshore winds veering north now, the weather is coming in fast from behind me — beneath rushing cloud the light and colour of the sea are changing all the time.

The squall comes without warning. The light level drops and the wind rises, then it starts to rain: a hard slant rain that is so loud on my raincoat I think at first it must be hail. I run for the shelter of a bench and crouch behind it, almost out of the wind. Although everything has darkened, the rolling sea is pale, waves breaking as far out as I can see, their wind-whipped crests filling the air with spray. I can barely see the island now, and the headlands have vanished. From this protected spot it is wild, beautiful out there.

Then from below me, from somewhere deep inside the ground, comes a hollow boom. For a moment it is unnerving. It comes again, and in the strange, pale gloom I realise it is the sea. Waves are rushing into a fissure in the rock almost beneath me, trapping air and compressing it, forcing it to explode inside the cliff.

It is a process that has shaped this coast over centuries, and millennia. The waves undercut the cliffs, eating into them and wearing them away, and all the stages of their erosion are scattered along this coast. The rock's initial weaknesses, or faults, become fissures, and in heavy seas are slowly hollowed out. Gradually the land retreats, through a series of wave-sculpted forms: sea cave to blow hole, to collapsed cave, to arch, to stack, to stump — like the line drawings we were shown in geography.

They are evocative features. The Cornish coast has the chasm Hell's Mouth and a collapsed sea cave known as The Devil's Frying Pan, as well as The Devil's Bellows and 'Ship-my-pumps' blowholes — the latter presumably renamed. There is the Tea Hole, and Creeping Hole, and caves that include Cathedral Cavern and the legendary Ralph's Cupboard, where the giant Ralph the Wrath was said to store the crews of passing ships before he ate them. Although Newquay's Banqueting Hall Cavern is now long gone, in the 1920s and 30s, on very low tides, a harmonium would be lowered from the cliff for concerts to be held inside the cave.

Around the British coast the strange, often eerie, acoustics of sea caves have inspired music as well as legends. Fingal's Cave, a sea cave on the Hebridean island of Staffa,

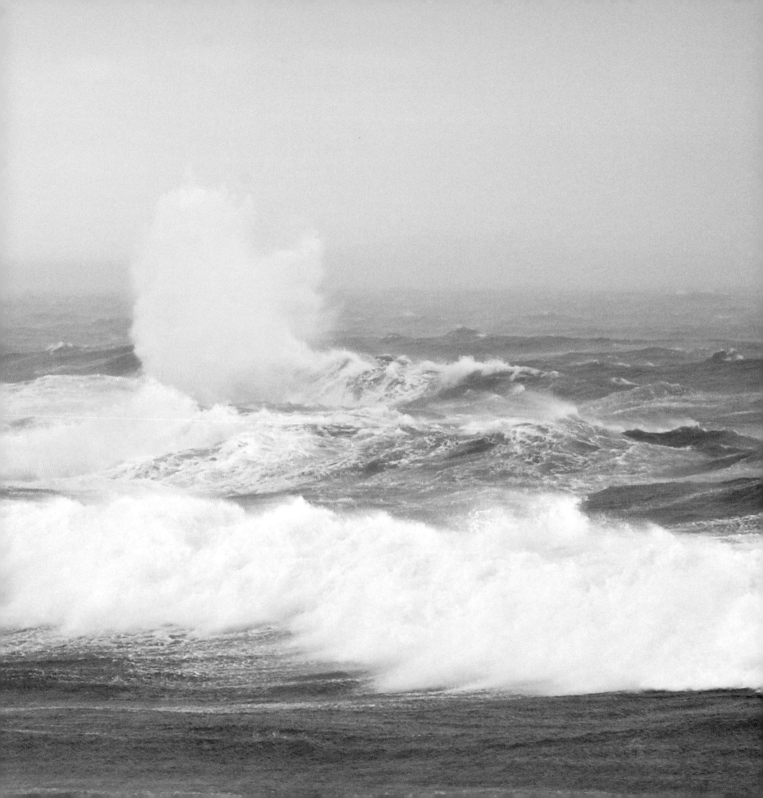

was the inspiration for Mendelssohn's overture *The Hebrides*. The cave's Gaelic name, *An Uaimh Bhinn*, translates as 'the melodious cave', and the cathedral-like echoes of the waves there inspired the tone poem's opening, which evokes loneliness and solitude with cellos and bassoons.

Unsurprisingly, music is common to a number of legends surrounding sea caves in Britain, as is the idea that these dark openings may be entrances to Hell. Similar stories are told on both Scotland's west coast and on the Isles of Scilly, of musicians — sometimes fiddlers, usually pipers in Scotland — that enter the caves and are never seen again. A dog returns, blackened and bald from the fires of Hell, but the musician is lost. He plays on though, his ghostly music echoing beneath the land forever. As I crouch behind the bench, with the sound of the sea still deep inside the earth, it is easy to imagine.

Within minutes, as quickly as it came, the squall passes. The wind eases and the sky lightens, and distant headlands reappear. The sun comes out. Trethias Island, which is for now — and some time yet — a stack, re-emerges from wind-blown spray.

by-the-wind sailors

Head down against the wind, I see one and then another close by. When I look about I realise there are hundreds, perhaps thousands of them: delicate, translucent skeletons of by-the-wind sailors, scattered along the strandline and tangled in amongst the weed. Whilst many are like the five I found in summer — intricate cellophane sailboats — others are more recently stranded, retaining at least some of their blue jelly-like base and fringe of tentacles. On a few the sail too is rimmed with iridescent blue.

A distant relative of the jellyfish, by-the-wind sailors spend their lives in vast flotillas on the open ocean. At this time of year though, it's not unusual for large numbers to wash ashore after gales. Occasionally, as in Ireland in 1992, they strand in their

stranded by-the-wind sailor, its sail reflected in the wet sand

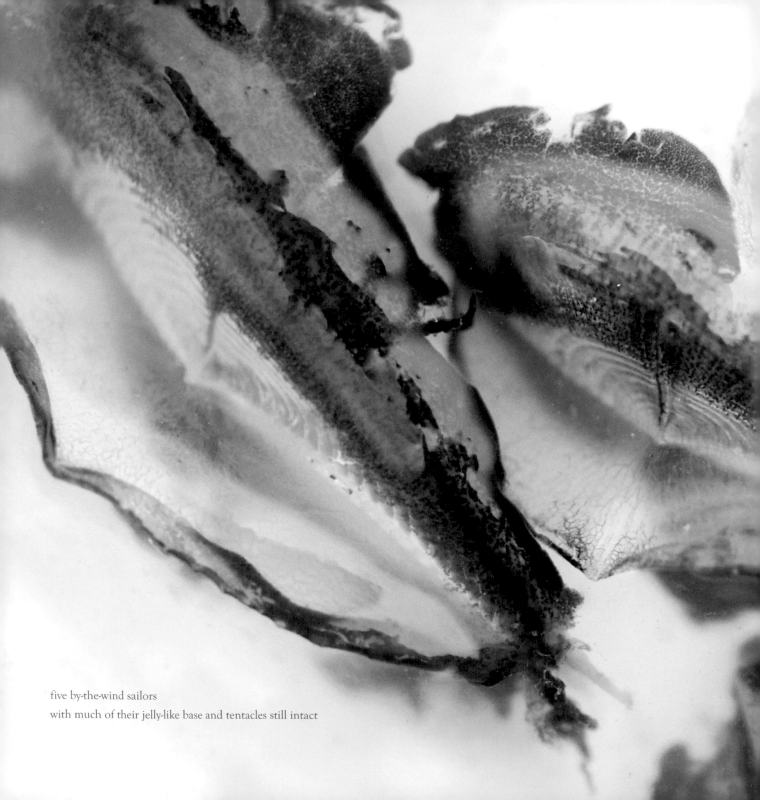

five by-the-wind sailors
with much of their jelly-like base and tentacles still intact

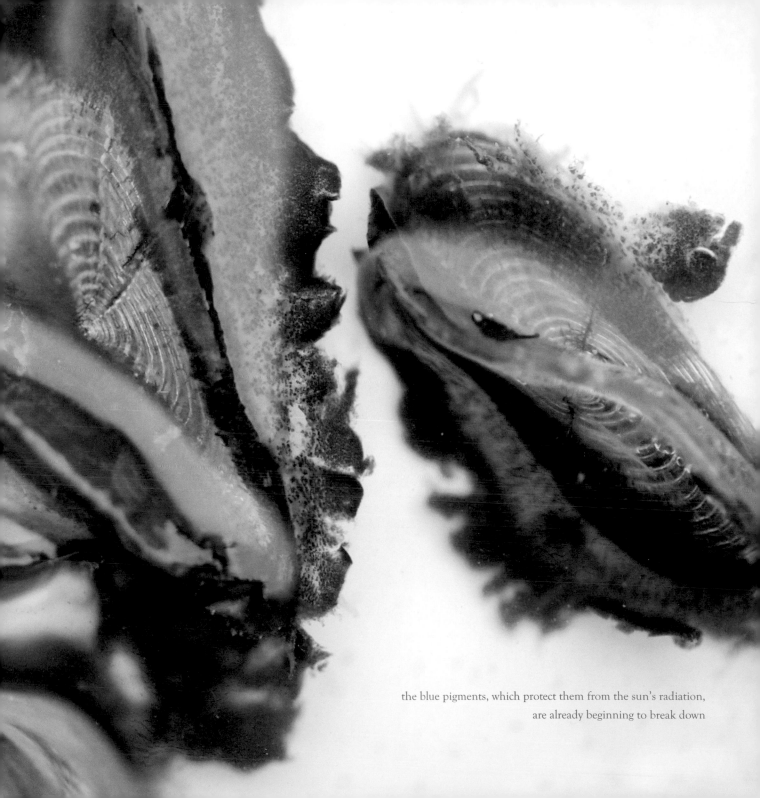

the blue pigments, which protect them from the sun's radiation,
are already beginning to break down

millions. The beautifully engineered sails, an inch high at most, run diagonally across the float and twist either to the right or left, which means the same wind will send the two forms tacking in different directions. So whilst the majority of those stranding on Britain's Atlantic shores twist to the left — as these do today — most of those found on the west coast of America twist to the right.

As always when I find a large number of by-the-wind sailors, I keep an eye out for a remarkable creature that preys on them: the violet sea snail. Similar in size and shape to its land cousins, this delicate snail has found a very different, apparently unique, solution to life on the open ocean. Its entire life is spent upside down, suspended just beneath the water's surface by a raft of bubbles it creates by agitating its own mucus with its foot. Unable to swim, the snail drifts wherever the currents take it, feeding when it bumps into a by-the-wind sailor or, more incredibly, a Portuguese man-o-war, as it is unaffected by their powerful sting. Although I find several mermaid's purses, sadly — as always — there are no violet sea snails, not even a fragment of shell. I have my head down, still peering intently, when the rain arrives.

It comes in gusts, driven in from the sea over wet sand, and when I scan the beach the few dog walkers here earlier have gone. I'm a long way from the car. Spotting a dark opening in the cliff up ahead, I make a run for it, ducking inside out of the rain. I stand dripping in the gloom. It is a small sea cave, with a floor of damp sand that in a few hours' time will be completely submerged.

As my eyes adjust to the darkness I see a big softwood tree-trunk at the back, perhaps washed in on the last high tide. It is barely visible beneath a colony of goose barnacles: big, mature adults with bluish plates at the end of their long, black goose-necks. It is too dark to take a photograph, so I reach out, thinking perhaps I could shift the whole thing closer to the light. It is too big though, and rotten, and as pale wood breaks off in my hand the fleshy necks of the nearest barnacles writhe. Only slightly, but enough — the darkness and my imagination do the rest. I almost bolt out into the

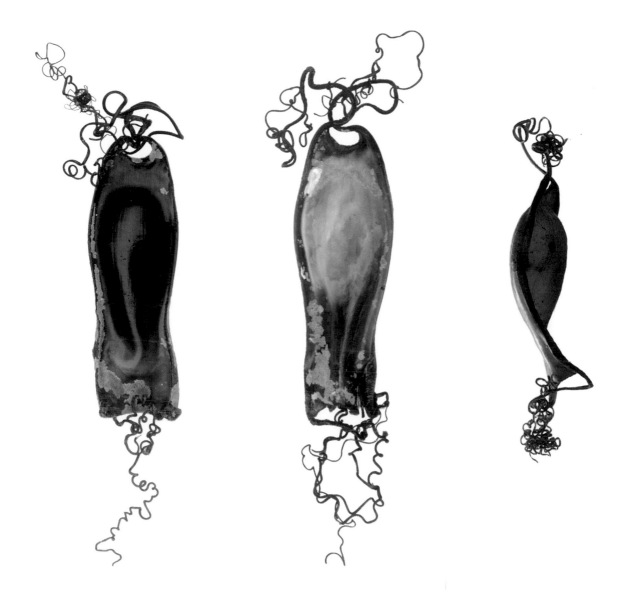

mermaid's purses: empty eggcases of the nursehound shark (*left and centre*) and a dogfish (*right*)
a single embyonic shark — a pup — lives inside each egg case for up to eleven months,
the length of time varying with the temperature of the water

rain. I'd read that in the past colonies of goose barnacles were sometimes mistaken for sea monsters, but it's only now I see why.

The rain eases, then finally stops. As I head back the westerly wind picks up, stronger gusts catching the papery remains of by-the-wind sailors and sending them skittering past me up the beach.

the shape of the wind

An hour later I pull into an empty car park on the cliffs above Bedruthan, a few miles east of the sea monster's cave. The stone cafe is closed-up against winter and it feels blasted up here, exposed; to open the car door I have to push against the wind.

Half a mile on, standing on the cliff-top with its sheer 100-foot drop to the sea, it feels like the edge of the world. Although the sky is darkening to the west, out at the horizon the sea is vanishing through veils of distant rain. There is no shelter, just a low ridge beside the worn-earth path, and I crouch against it as the weather comes in.

It isn't rain when it arrives, but hail. Small, pelting hail that bounces off the dirt all around me. Great gauzy curtains of it billow in across the sea, showing me the shape of the wind. It strengthens, until even the nearest cliffs and stacks are spectral through the whiteness of the hail. I shrink down against the ridge, trying to get beneath the wind.

After ten minutes the squall passes through — as so often it does on this coast — and I emerge, dry down one side but soaked through to the skin on the other. It is a cold walk back to the car. Yet after weeks spent mired in work at a computer, I am surprised to find I am entirely restored. It seems that sometimes what's needed is to stand on a cliff in a hailstorm.

DECEMBER

winter strandline

The early drive to school takes us down into the shadow of a valley, and today beyond the trees the rough pasture glitters with frost. Bare twigs and last leaves are edged in white, and where water lies along the rutted edge of the track slivers of ice have formed. We emerge on the far side to blue sky streaked with cirrus. My daughter is eight and her topic this term is the weather; from under a blanket on the back seat she recites the names of the clouds she likes most, and cirrus is one.

Twenty minutes later I'm alone on the beach below the valley. Most is in the blue shadow of the cliff, and after the warmth of the car the air on my skin is icy. I make my way to one end of the strandline — methodical, not wanting to miss something — and head instinctively for the side in the sun. These cold, still days follow three unsettled weeks and the weed is heaped richly at my feet: glistening wracks and red rags, dead man's rope, oarweed with its fringes of dulse.

Rooting through it, one remarkable creature I find on the dulse is the star sea squirt (right). To the surprise of many — myself included — sea squirts are classified in the same major animal group as humans, the phylum Chordata. This is because their free-swimming larvae have a primitive backbone, a notochord, which is lost as they take on their adult form. Star sea squirts are colonial, with individuals sharing an outer 'tunic' and drawing water in through their bodies by beating hair-like cilia.

Each petal of the flower shapes is an animal, arranged around a communal opening. I also find them on rocks here at low tide, and although the colours are usually some contrasting combination of yellow with brown or blue-grey, the variety of the petals is extraordinary. Unlike the wildflowers they resemble, no two colonies I've found have been alike.

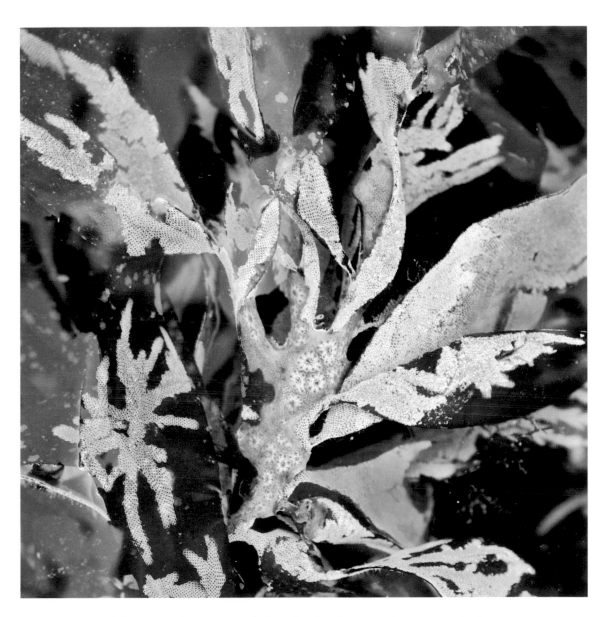

dulse encrusted with sea mats (pale grey) and at the centre a 'star sea squirt' colony

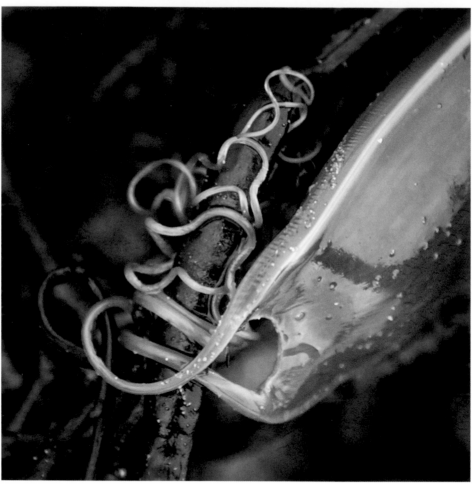

empty egg case of a dogfish, its wiry tendrils still coiled tightly around
the sea oak, or pod weed, it was laid on

As always this time of year, much of the oarweed and dulse is patterned with colonies of sea mat, or sea lace (page 151). These extraordinary 'moss animals' form lacy structures of minute boxes or cells, each attached to its neighbours by flexible joints. The shape of the cell is unique to each species — rectangular perhaps, or oval — and each is home to a tiny, tentacled animal. The tentacles are extended to catch food, made more efficient by the swaying motion of the seaweed. The benefit, though, is not shared — as the mat spreads it blocks light, and for the seaweed this hinders photosynthesis. So the winter gales do a fine job of clearing out this old and weakened growth to make room for the new.

When I reach the far side of the beach it is still deep in shadow. Frost glitters here too, although only at the strandline: at rope-ends, at the flayed edges of a plastic bottle. I spend a while carefully untangling the tendrils of two mermaid's purses — these both egg cases of a dogfish, or lesser spotted catshark — before realising I'm underdressed and freezing, and could do with a coffee. I straighten up and scan the empty beach, and as always these days, after looking so closely for so long, find at first I can't focus my eyes (if I've been looking through the camera the whole time it's just the one eye). More careful now than at times in the past, I wait until I can see before starting the car.

Later that cold and starry night I drive my son back from Scouts through the valley, and as we drop downhill the temperature gauge on the car begins to fall. It is a frost hollow, like others around here, where cold air — heavier than the rest — rolls down from surrounding hills and is held at the valley floor. There is no moon, or lights out here, and as we drive on through the darkness suddenly the road ahead of us is steaming. We stop, astonished. Caught in the car's headlamps, as if lit for a film, mist is peeling off puddles and run-off and the stream. It is all around us, curling upwards, hanging a few feet above the ground. When I glance over at my son he is leaning forwards, peering out into the night. Our familiar road is now a place where anything could happen.

dogfish egg case after drying

losing the light

I didn't intend to come here, but the road-closed sign up ahead means this is as far as I can go. It is the beach with the cafe that was engulfed by sand in last winter's storms, and although the shelters have been rebuilt over summer — those furthest inland, anyway — great chunks of the old sea wall still lie at broken angles on the beach. I clamber down over them, heading for the rocks where I sometimes see cormorants.

After the brief cold snap these have been days of low sun and least light, of fast-changing skies the colours of old bruises. It has been an ongoing spectacle of distant weather — of towering cloud ragged with fall streaks, yellowed horizons and gold linings, of theatrical cloths drawing back to reveal a day-moon. Weather fronts are again snaking across Britain, and we are back to noticing clouds the way we did last winter. Recently caught out not-knowing by my daughter, I've found myself looking out our old books of clouds, with their diagrams and heights and lists in Latin, and have tried again to retain some of the names.

Like the scientific classification of plants and animals, clouds are divided into ten main genera, by height and appearance, then subdivided into species and varieties. The common kind we draw as children are cumulus, from the Latin for 'heap'. These range from the fluffy humulis — 'humble' — through mediocris to the taller and sometimes rain-bearing congestus. Taller still, growing up to 11 miles high, is cumulonimbus, the King of Clouds. Heavy with rain or ice, these clouds can weigh as much as many thousands of blue whales (though even the airiest puff of humulis apparently weighs more than an elephant). Originally the ninth genera in *The International Cloud Atlas* of 1896, cumulonimbus, this tallest of clouds, is the origin of the phrase 'cloud nine' — although a rearrangement in the second edition shunted it to number ten, where it's remained.

The low, featureless cloud layer so common here in Cornwall is stratus, often the species nebulosus, although it may also be fractus (broken), undulatus (wavy) or

translucidus (thin enough to see the disc of the sun or moon). As in the past, I become wonderfully bogged down in the names. I discover clouds may be lacunosus (holed) or castellanus (turreted on top). They may be intortus (with fall streaks that are tangled) or vertebratus (with filaments like the skeleton of a fish). I find the King of Clouds will be either bald or hairy.

I head west along the shore, its grey sand returned by the waves over summer, and although it's only early afternoon there is already a low flush to the sky. Against it the streak of cloud at the horizon is dark. Stratocumulus, I think, without conviction. Nimbostratus? Cumulus. Stratus. I've no idea. Like the clouds themselves, the names are already drifting away, merging, shifting from one form to another. It doesn't help that since the children's Harry Potter phase, Latin has begun to sound like spells.

When I reach the rocks, the cormorants are there, their tiny island far enough out that they're not disturbed by my approach. I watch one scramble awkwardly out onto the rock, and even at this distance can see its feet are huge. I found the body of a cormorant once, left high on shore by the tide, and it was its beautiful swimmer's feet that struck me most. Black and reptilian, they are webbed across all four toes, and are used to both propel and steer as the bird chases fish underwater. Watching it climb the rock now though, its feet seem something of a handicap.

I dig out gloves and a hat. It is colder again today, and you can smell the change, the air bringing with it that trace of where it's come from. Yesterday's warmer maritime air, with its southern Atlantic damp, has again been replaced by the clean cold of polar air. It is this frontline between the warring air masses, where the heavier cold burrows beneath the warm, that is the cause of all this drama of the skies.

Against the low sun, the cormorant shuffles towards the others, stops, then opens its wings in the eerie pose often referred to as a crucifix. Like the others it stands angled for the breeze, motionless most of the time but now and then drawing its

wings back and forth as if rousing an audience. As well as drying the wings — a cormorant's feathers are less waterproof than most to reduce buoyancy — the pose is also thought to speed up the digestion of cold fish. It also makes it easy to see why cormorants have often been symbols of death and the Devil. In Milton's *Paradise Lost* a cormorant is Satan's chosen disguise, while in Norway they were seen more favourably, as messengers of the dead carrying home word from those lost at sea.

I turn back. Although it is only mid afternoon, I am already losing the light. In two days it will be the winter solstice, from the Latin meaning 'the standing still of the sun'. That moment on the shortest day will be the turning point of the year, the reversal of the ebbing sun, when the days will once again begin to lengthen. This transition from darkness to light has been marked with ritual and celebration since ancient times, evident in prehistoric monuments aligned for the first light of the solstice sunrise. And whilst today it is often missed amid the commercial frenzy of Christmas, many of those traditions have their roots deep in the pagan midwinter festivals of fire and light, of rebirth and renewal, in the 'Birth of the Unconquered Sun'.

storm force 10 expected later

I wake early and catch the 0525 Shipping Forecast:
South or southwesterly storm force 10 expected later. Rough or very rough, becoming high for a time.
The local forecast says the storm is due here around midday. So after dropping the children for school I pack up my camera — with waterproof bags to protect it — and head for Lansallos.

The tiny village, half a mile inland, is deserted. The wind has picked up steadily over the last hour, but in the shelter of the lane it still feels elsewhere. It blows through the telephone wires overhead as if through rigging, the sound eerie, evocative — it seems a long time since I've been out in weather quite like this. The village ends at

the old graveyard, and I take the path down through the valley to the sea. Leafy and enclosed, the wind seems more distant here than in the lane.

Then the path opens out and curves west, and I feel the wind. Through trees I glimpse the field alongside, and it is a moment before I make sense of what I'm seeing: scraps of sea-foam blowing past me up the valley, a fair way inland.

As I come out onto open land above the cliff the wind is extraordinary. It is wild and onshore. I lean into it, make for the short run of fencing above the cove. At times it stops me in my tracks and sends me backwards; it's ok, I think, it will blow me inland.

I make it to the nearest fencepost and hold on, unable to stand still without it. The sound of wind and water is exhilarating. I hold on to the wire as I move along it, gripping, looking for shelter — but with the wind so directly onshore there is nothing.

I hang on to the wire. Out in the bay the grey sea rolls, the waves white with foam and flashing a glassy green as they break. Near shore everything is pale, the air filled with sea-spray, the outline of the cliffs indistinct. White horses surge into the cove from all directions. There is barely any beach. Down below it is a cauldron, the sea trapped there, roiling and wild. Close to shore the wind whips it into creamy foam and great dollops tear off, spiralling up on crazy air currents to coat the face of the cliff.

It is not just foam in the air. Sheets of spray blow up over the cliff and cling to my face. I can taste the salt, can't tell if it's raining. With cold hands I struggle to bag the camera in the wind. I can barely hold it still. The lens waves around, the glass instantly soaked and misted up. The bag flaps madly in the wind.

I take a few frames but can already see there is barely anything there. The wild scene is indistinct, flattened, without atmosphere. My camera can capture nothing of this, no sense of how it feels to be here. I put it away, and stand facing into the wind.

gulls, & change

Two days later I return to the same cove, and this time follow a narrow path out through wind-stunted gorse to a spot where you can climb down to fish from the rocks. The weather has settled down but is still skittish, all ice-blue skies and glinting sunlight then blowing up in brief and sudden downpours. The sea is only a little less wild than it was, and as I've done before here after gales I pour coffee and settle down to watch the gulls.

With a big swell running, they tend to gather in places like this, where peculiarities of the shore and seabed mean bigger waves (if we know what we're looking for, the way a wave breaks shows us the shape and shelve of the sea floor). Today, with the surf and light as they are, the gulls are mesmerising. At times there are thirty or more — mainly black-backed and herring gulls — out where the most powerful waves are churning fish to the surface. I watch from a hollow in the gorse, singling gulls out with the lens as they sweep along a trough, dwarfed by the gleaming face of the wave. Then as it breaks, crashing into white water and bearing down on the rocks, they lift away into the wind-torn spray, airy and blithe, to try again.

I wonder if we're in for another stormy winter. It was around this time last year that we began to see weathermen on the main news, with satellite images that pulled out and drew away from Earth to see our weather from space. For the first time ever I overheard conversations about the jet stream in local shops. It had our attention, this battlefront of air masses that had shifted course and was 'stuck' over Britain.

On the same news, scientists talked of likely causes: of warming oceans and melting icecaps, of carbon dioxide levels in the atmosphere, of our wastefulness and reliance on fossil fuels. They gave evidence of our changing climate, said in future Earth's weather will become more extreme. And for a while — seeing on

screen our own storm-battered seafronts and drowned homes, our train tracks swinging in the wind – there was perhaps some urgency to our concern. But then the weather settled down. The jet stream shifted, moved on elsewhere, and with it our attention.

For most of us it is not easy to alter our perspective, to pull out and see change on a greater scale than our own lifetime. As a consequence, time after time this year I have been blown away by those glimpses of change over vast, unimaginable timescales.

Britain, with its familiar shape and weather and inhabitants, no longer feels quite the same place. I've pictured it now as it was in the past, and may well be in future: a land of tropical rainforests and mangrove swamp, of vast ice fields or rust-coloured deserts. I've traced North Sea sandbanks that were once the crests of hills, touched a prehistoric forest in the sea. I've glimpsed creatures that flourished in those climates and environments – ammonites, plesiosaurs, 'serpents threaded through turtles' – but were unable to adapt to their changing world. I've seen the bones of whales that had legs.

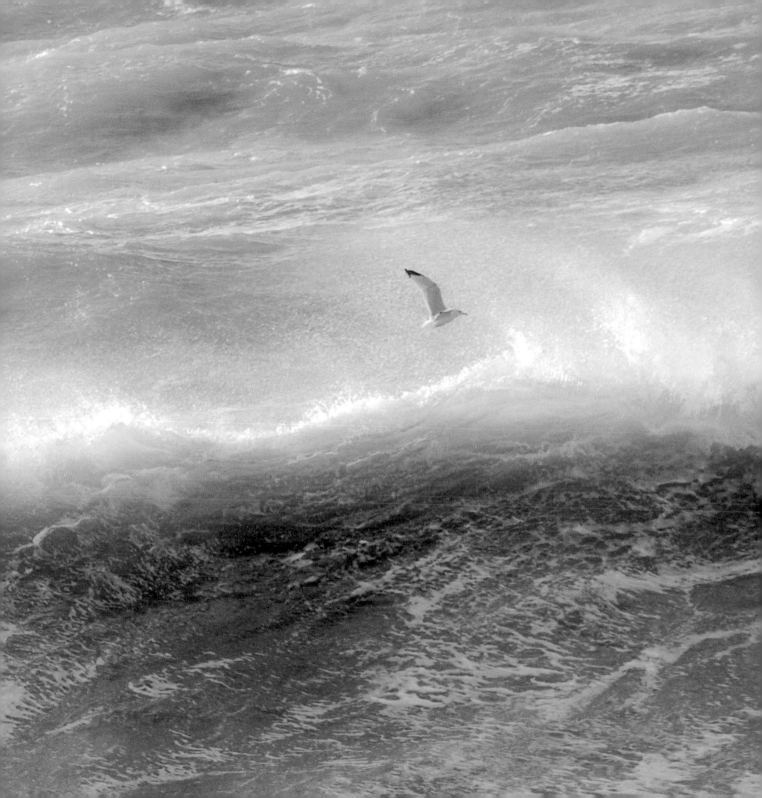

Mostly though, I've rooted about on the shore, often not far from where I live, discovering and rediscovering some of the extraordinary species that are the result – for the time being – of those millions of years of evolution. Things as wondrous as a cuttlefish or by-the-wind sailor, as buoy barnacles, red seaweed and star sea squirts. And learned of evolutionary solutions as specific and perfect as byssus thread and mucus bubble rafts, luminous lures and mermaid's purses – or as magnificent as the sperm whale's nose.

I sit for hours, long after the coffee's gone cold, wet and then dry and then wet again. Several times I pack up to go. But then the light changes, or there are more gulls or a promising wave, and I settle back down.

We should remember that however wonderful an adaptation, there is nothing inevitable about the particular species that are alive today, as all have evolved from ancestors that just happened to survive Earth's five mass extinctions. The worst of these is often referred to as 'The Great Dying', which 252 million years ago wiped out something like 96% of life on Earth. So all life that exists today has evolved from the 4% of species that survived it. Before the most recent of the mass extinctions, for example, ammonites were far more successful and widespread than the nautilus, but it was the nautilus that made it through – and so whose descendants inhabit our oceans today (the reason is thought to be that the nautilus's larvae live at greater depths, so were less vulnerable than the ammonite's at the surface).

Although all the mass extinctions involved climate change, each appears to have been very different. The first, 444 million years ago, began with glaciation; The Great Dying with global warming and its related changes to ocean chemistry. The most recent, which wiped out the dinosaurs and ammonites 65 million years ago, appears to have been caused by an asteroid collision and subsequent 'impact winter'. What they do have in common though, is the *rate* of the climate change: that it was too fast for species to adapt in time.

There is growing concern that the Earth has now entered another period of significant extinction, this time driven by man. The supporting data is increasingly disturbing. If we continue consuming at current rates, by the end of this century our oceans will be 150% more acidic than they were at the start of the industrial revolution, which is regarded as the 'tipping point' at which many species start to crash. In half that time the coral reefs, those richest of ecosystems, will have begun to dissolve. So while the predicted level of climate change alone is not enough to cause extinction on the scale of the 'big five', when combined with man's other activities — such as over-fishing, pollution, our spread of 'invasive' species around the globe — then perhaps it could. The fear is that with all this coming at once, the rate of change in the environment will once again, as with previous mass extinctions, become too rapid for life to adapt.

If we make no changes then millions of years from now, when all that remains of our cities and factories and plastic is a narrow band of sediment in the rock, it may well show a dying out of species on the scale of a sixth mass extinction.

corrosion

I get a call from the camera repair shop.
'It's about your D700,' the man says. 'You know there's a lot of corrosion?'
He talks for a while about water and salt corrosion, stuck dials, a rusting flash and sand behind buttons. There are limits, he says, to what he can do.
He sighs. 'You need to be strong just to turn it on.'

They send it back and it works, for a week. Then the button sticks again. It turns out though there is a way to work around this, and — so far — I am finding it surprisingly easy to ignore the rust creeping in at the edges of the viewfinder.

further reading

Almost Like a Whale: The Origin of Species Updated, Steve Jones (Anchor, 2000)

The Book of Barely Imagined Beings: A 21st Century Bestiary, Caspar Henderson (Granta, 2012)

The Cloudspotter's Guide, Gavin Pretor-Pinney (Hodder & Stoughton, 2006)

Coast: Our Island Story, Nick Crane (BBC Books, 2010)

Darwin and the Barnacle, Rebecca Stott (Faber & Faber, 2004)

The Edge of the Sea, Rachel Carson (Staples, 1955)

The Essential Guide to Beachcombing and the Strandline, Steve Trewhella & Julie Hatcher (Wild Nature Press, 2015)

The Fabled Coast, Sophia Kingshill & Jennifer Westwood (Arrow, 2014)

Flotsametrics and the Floating World, Curt Ebbesmeyer & Eric Scigliano (Harper Collins, 2010)

The Fossil Hunter, Shelley Emling (Macmillan Science, 2011)

A Grain of Sand, Gary Greenburg (Motorbooks, 2008)

Great British Marine Animals, Paul Naylor (Sound Diving, 2011)

Kraken: The Curious, Exciting, and Slightly Disturbing Science of Squid, Wendy Williams (Abrams, 2011)

Leviathan or, The Whale, Philip Hoare (Fourth Estate, 2009)

London Clay Fossils from the Isle of Sheppey: A Collector's Guide, Frederick Clouter (Medway Lapidary & Mineral Society, 2000)

Mapping the Deep: The Extraordinary Story of Ocean Science, Robert Kunzig (Sort Of Books, 2000)

The Moon: A Biography, David Whitehouse (Headline, 2001)

The Naming of the Shrew: A Curious History of Latin Names, John Wright (Bloomsbury, 2014)

Ocean Drifters: A Secret World Beneath the Waves, Richard Kirby (Firefly Books, 2011)

Ocean of Life, Callum Roberts (Allen Lane, 2012)

The People of the Sea: A Journey in Search of the Seal Legend, David Thomson (Granada, 1980)

Photographic Guide to the Sea and Shore Life of Britain and NW Europe, Gibson, Hextall & Rogers (Oxford University Press, 2001)

The Sea Inside, Philip Hoare (Fourth Estate, 2013)

Seasearch Guide to Seaweeds of Britain and Ireland, Bunker, Brodie, Maggs & Bunker (Marine Conservation Society, 2010)

Strands: A Year of Discoveries on the Beach, Jean Sprackland (Jonathan Cape, 2012)

The Sixth Extinction: An Unnatural History, Elizabeth Kolbert (Bloomsbury, 2014)

The Wavewatcher's Companion, Gavin Pretor-Pinney (Bloomsbury, 2011)

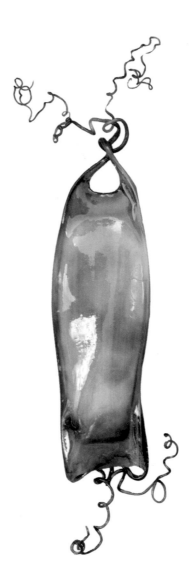

Licensed exclusively to Top That Publishing Ltd
Tide Mill Way, Woodbridge, Suffolk, IP12 1AP, UK
www.topthatpublishing.com
Copyright © 2015 Tide Mill Media
All rights reserved
4 6 8 9 7 5 3
Manufactured in China

Written and illustrated by Bethany Rose Hines

ISBN 978-1-78445-104-2

A catalogue record for this book is available from the British Library

'for my family'
Lots of love Beth

That's not funny, Bunny!

by
Bethany Rose Hines

Bunny just wanted
to be different.
He was always dressing
up in silly clothes,
trying to impress
his friends.

Bunny twirled and swirled like a beautiful ballerina.

But his friends only said,
'That's not funny, Bunny!'

Bunny just loved wearing silly hats and funny wigs.

But his friends only said, 'That's not funny, Bunny!'

Bunny put on
a cape and became
a superhero!

But his friends only said,
'That's not funny, Bunny!'

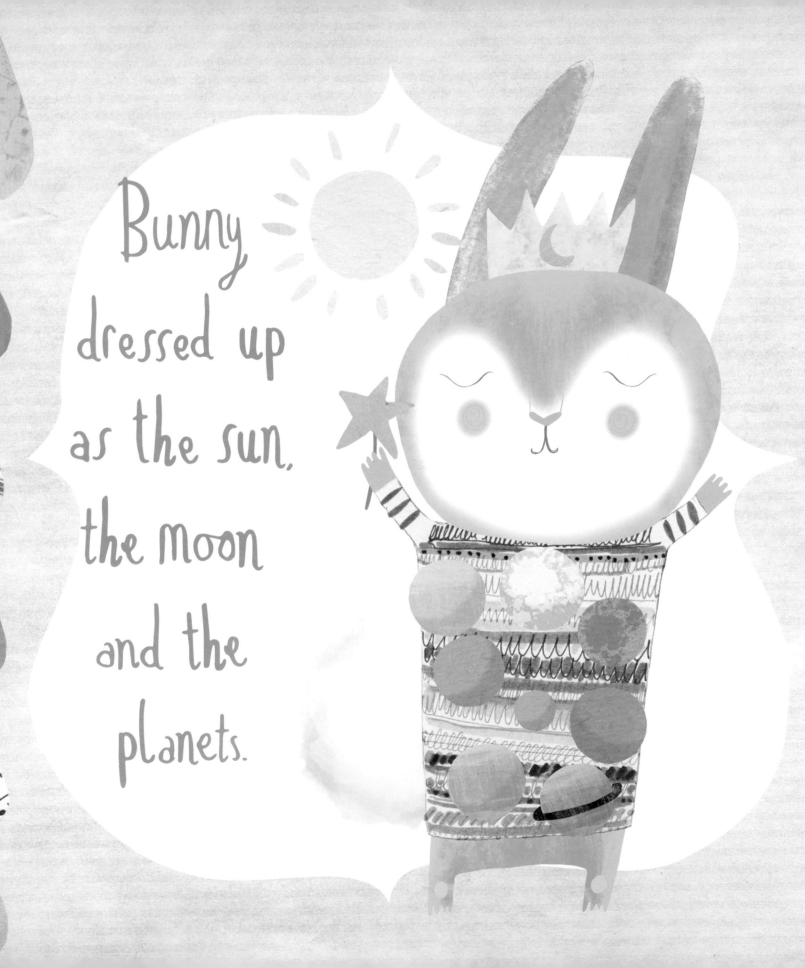

Bunny dressed up as the sun, the moon and the planets.

But his friends only said,
'That's not funny, Bunny!'

He puffed out his chest like a great big, hairy bear.

But his friends only said, 'That's not funny, Bunny!'

Bunny dressed
up as his
favourite
treat—
a strawberry
cupcake!

Although his friends thought he looked delicious, still they only said, 'That's not funny, Bunny!'

Bunny was sad.
He couldn't seem
to do anything to
impress his friends.

'Don't be sad,'
said Fox.
'I love your
soft, velvety
ears just
the way
they are!'

'And I love your fluffy, bouncy tail just the way it is!' said Cat.

'And I love your big heart just the way it is!' said Deer.

Bunny was so happy!
He didn't have to try
to impress anyone at all.
All of his friends loved him
just the way he was.